IMAGES
of America

GERMAN CINCINNATI

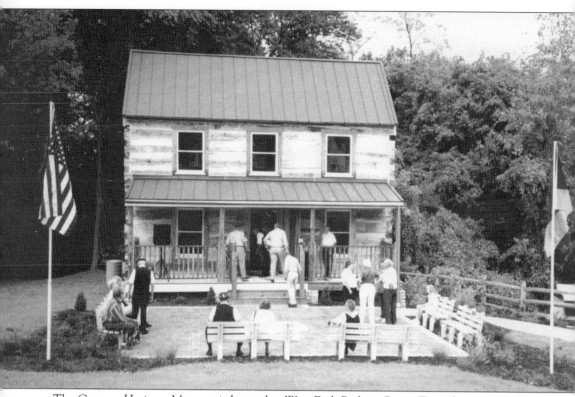

The German Heritage Museum is located at West Fork Park in Green Township.

IMAGES
of America

GERMAN CINCINNATI

Don Heinrich Tolzmann

Published by Arcadia Publishing
Charleston SC, Chicago IL, Portsmouth NH, San Francisco CA

Printed in Great Britain

Library of Congress Catalog Card Number: 2005933411

For all general information contact Arcadia Publishing at:
Telephone 843-853-2070
Fax 843-853-0044
E-mail sales@arcadiapublishing.com
For customer service and orders:
Toll-Free 1-888-313-2665

Visit us on the internet at http://www.arcadiapublishing.com

CONTENTS

ACKNOWLEDGMENTS

Vielen Dank to all those who have been of assistance in some way during the course of my research on the German heritage, especially the following: Frances Ott Allen, Kate Barone, Kenny Buerck, Jerry Glenn, E. P. Harris, Anna Heran, Donna Kremer, Richard Erich Schade, Manfred Schnetzer, Stephanie Splete, Jay Yocis, and Manfred Zimmermann. A special word of thanks goes to Kevin Grace for all of his great support.

 Vielen Dank also to students of my courses in German-American Studies at the University of Cincinnati and to members of the German-American Citizens League of Greater Cincinnati, as well as other German American societies of the area.

 Above all, *besten Dank* to my wife, Patricia, and the rest of the Tolzmann clan—Anna Maria, Katherine, and Christian—for the many ways they have helped.

—Don Heinrich Tolzmann, University of Cincinnati

INTRODUCTION

Greater Cincinnati forms something quite unique. It, along with Milwaukee and St. Louis, creates one corner in the famed German Triangle, where it is one of the top three urban areas in the United States known for its German heritage. Today, almost every other person here has some German ancestry. Such a substantial element of the population is bound to have played and continues to play an important role in the social, cultural, and political life of the area. Clearly, to understand the history and development of Greater Cincinnati, it is necessary to take the German heritage into consideration.

So much of this German ancestry has become an integral part of what is considered Cincinnati that it is often taken for granted as the norm, or as the American way of life. However, on closer inspection, the German roots become readily apparent. One might even conjecture that an *Ausländer* coming to Cincinnati might more easily perceive the Germanic character of the area than those who have grown up there. Some might not realize that the Cincinnati Way might more correctly be described as the Cincinnati German Way. The German dimension is omnipresent.

German Cincinnati provides a pictorial survey of people, places, and things German in Greater Cincinnati and is intended for those interested in learning more about the area, the German element, and their impact. This work represents a new venture for me, as my modus operandi has mainly been that of the historical narrative, although I have also edited literary works to illuminate the German heritage. An illustrative history such as this, however, offers an opportunity to explore the German heritage in ways that historical and literary narrative cannot, and it is my hope that this work will serve as another contribution on my part to an understanding and appreciation of Greater Cincinnati's German dimension.

Chapter One surveys the landmarks and sites that define the German image of the Cincinnati cityscape, while German immigration since the 18th century is traced up to the present time in Chapter Two. Chapters Three and Four examine the religious and social life that emerged out of the institutions and organizations founded by German Americans. Chapters Five through Eight explore the extraordinary impact German Americans have exerted on education, business, and industry, as well as the cultural life of the area. Chapters Nine and Ten provide an overview of the German American experience through times of war and peace, and bring the story up to date with a consideration of the German heritage of recent years. Finally, the book ends with For Further Reading for those interested in exploring topics only touched on here.

One

IMAGES AND SYMBOLS

The impact of the German element can be readily seen in the material culture of the area, ranging from landmarks, monuments, sites, structures, parks, cemeteries, and architectural styles. Taken together with Cincinnati's location, on the banks of the Ohio River, they provide a distinctly German-style cityscape, or *Stadtbild*. Some of these details may unfortunately have been blurred or even obliterated during World Wars I and II, or as a result of modern urban decay. Nonetheless, the broad outlines and features are clearly discernible as some of the most enduring aspects of the German heritage of the area. Taking note of them is the first step along the path of connecting to an appreciation and understanding of the German dimension of Greater Cincinnati.

German influences on the cityscape are not confined to the German districts and neighborhoods of the region, but can be found throughout the entire area. They range in date back to the 19th century and provide an index not only of the depth of the German imprint, but also of the status attained by German Americans, and their ability and success in integrating it into the landscape as a foundational element.

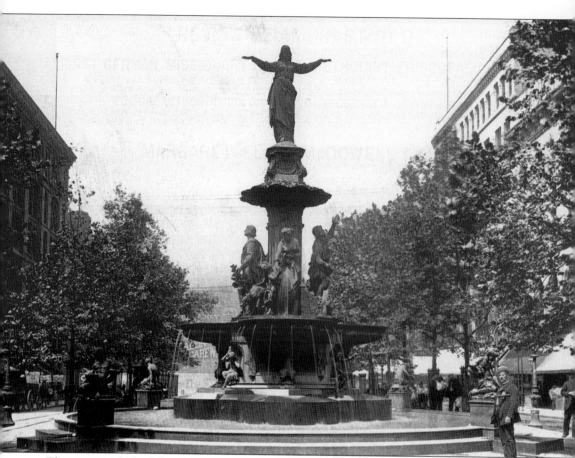

The very symbol of the city is a fountain from Munich, Cincinnati's official Sister City. A typical centerpiece for a German city, the fountain is altogether fitting for a city noted for its German heritage.

The fountain was designed by August von Kreling, cast by Ferdinand von Miller in Munich, and donated to Cincinnati by Henry Probasco in honor of his brother-in-law Tyler Davidson. It was dedicated in 1871 on a date significant for German Americans: October 6. Celebrated nationally as German-American Day, this date marks the founding of the first permanent German settlement in America at Germantown, Pennsylvania, on October 6, 1683. The fountain itself, therefore, has always been considered as a tribute not only to the city, but also to its German heritage.

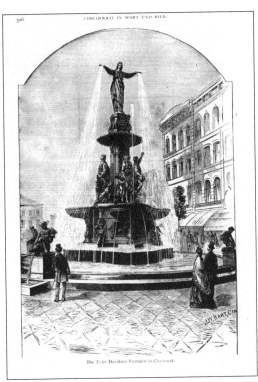

J.W.HART.CIN

Die Tyler Davidson Fontaine in Cincinnati

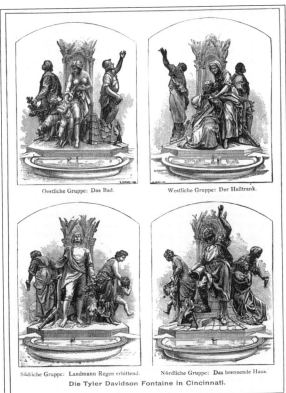

Oestliche Gruppe: Das Bad. Westliche Gruppe: Der Heiltrank.

Südliche Gruppe: Landmann Regen erbittend. Nördliche Gruppe: Das brennende Haus.

Die Tyler Davidson Fontaine in Cincinnati.

The 43-foot-high fountain is adorned with 13 allegorical figures and 4 bas-reliefs that depict the blessings of water. Its central figure is the *Genius des Wassers,* or the Genius of the Water, standing with outstretched arms that bestow water.

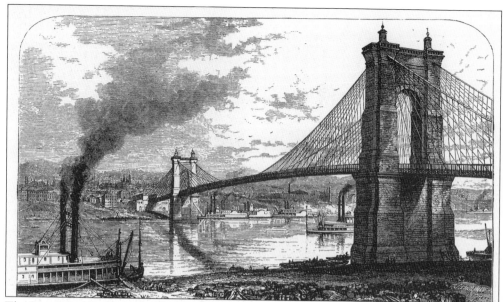

The Suspension Bridge across the Ohio River serves as the major landmark in Greater Cincinnati. Opened for traffic in 1867, the bridge was built by Johann August Roebling and served as the model for the Brooklyn Bridge, which was completed in 1883.

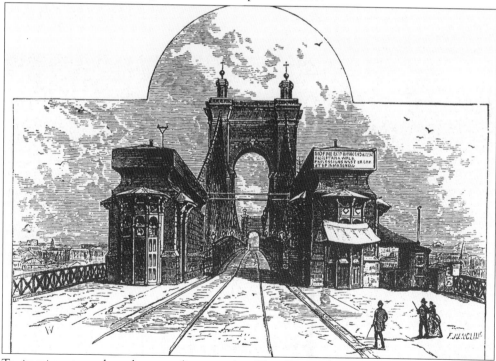

To immigrants and settlers traveling on the Ohio River, the Suspension Bridge became the guidepost alerting them that they had arrived in the Cincinnati area. The bridge itself demonstrated that America was, indeed, *das Land der unbegrenzten Möglichkeiten*, or "the land of limitless possibilities," as all could immediately see what Roebling, a German immigrant, had accomplished.

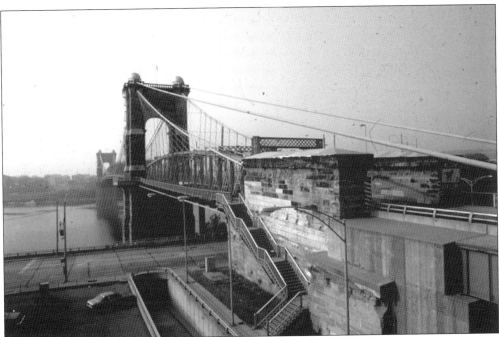

The Suspension Bridge also served to connect the city of Cincinnati with Covington, Florence, and Newport in northern Kentucky, which became an integral part of the region known as Greater Cincinnati. Due to its location in the Ohio River Valley, the area also became known as the American Rhineland.

The vast greenery that can be seen when flying over Greater Cincinnati is due to the more than 100 parks that beautify the region. This no doubt reflects the German love of woodland and forest. No other urban area of comparable size in the country can compare with the area in terms of the number and size of its parks. Some of them are as large as state parks found elsewhere and are filled with deer, raccoons, and possums.

Eingang zum Washington Park, an der Race Str.

Washington Park is one of the smaller inner-city parks, and due to its location in the Over-the-Rhine district, was the place where many German-style festivals were held. It also offered a favorite playground for children and a place for families to stroll on the weekend. D. J. Kenny wrote, "The area of the park is only ten acres, but it is a favorite place of resort particularly by the German children Over-the-Rhine."

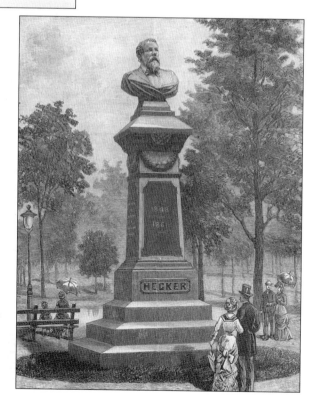

Washington Park is noted for its *Hecker-Denkmal*, or Hecker Monument. Friedrich Hecker (1811–1881) was one of the leaders of the 1848 Revolution in Germany and, after its failure, came to America along with thousands of other so-called "Forty-Eighters." The monument was constructed in the German American national hero's honor in 1883 and bears the German inscription *Mit Wort und That für Volksfreitheit im alten und neuen Vaterlande*, or "For the freedom of the people in the old and new Fatherland."

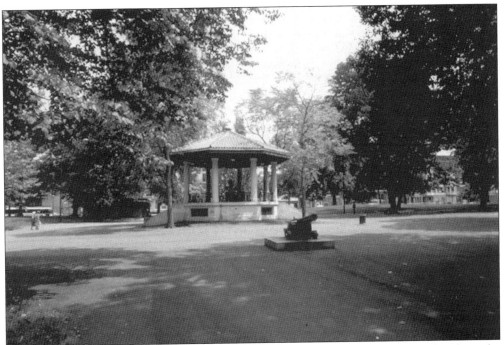

Numerous concerts were held in Washington Park by musicians, who also played in the Music Hall across the street from the park and in the beer gardens and restaurants in the Over-the-Rhine district.

The Jahn Memorial Monument is located in Inwood Park on Vine Street, north of the Over-the-Rhine district. Impressively situated on a hillside terrace overlooking the park, this monument honors Friedrich Jahn (1778–1852), the founding father of the Turner Movement in Germany. The Turner philosophy held to the belief in maintaining "a sound mind in a sound body," or of keeping both physically and intellectually fit. The Jahn Memorial Monument, dedicated by the Cincinnati Turnverein, was the product of local German American sculptor Leopold Fettweis (1848–1912), who created many sculptures in the area.

Spring Grove Cemetery is widely considered a masterpiece of landscaping artistry. Although its primary function is a cemetery, it also serves as a park that is recognized as one of the most spacious and naturally beautiful areas of Cincinnati. Chartered in 1845, the 782-acre Spring Grove is listed on the National Register of Historic Places and represents one of the finest gems in the crown of the Queen City of the West. Ask Cincinnatians which points of interest they bring visitors to see, and more often than not, Spring Grove will be among those most often mentioned.

German inscriptions can be found throughout Spring Grove, as well as in other cemeteries of the area. Max Burgheim wrote that Spring Grove could hardly be equaled with regard to its "natural beauty and idyllic landscaping charm," and that here "nature and art go hand in hand together to create a harmonious ensemble beneficial to the eyes as well as the heart." He noted that it reflected the citizenry of Cincinnati's "feeling not only for the departed, but also their artistic tastes."

Spring Grove became nationally known due to the work of its superintendent, Adolph Strauch, who had acquired his landscaping education in Germany and Austria. He introduced what were then considered revolutionary ideas and principles that placed an emphasis on nature. He described his reforms as the "landscape lawn plan" and called for a return to the "aesthetics of the beautiful." Strauch's skills were not confined to Spring Grove; he also designed Mount Storm Park in Clifton and played an influential role in the planning of the park system in Cincinnati, as well as the Cincinnati Zoological Garden.

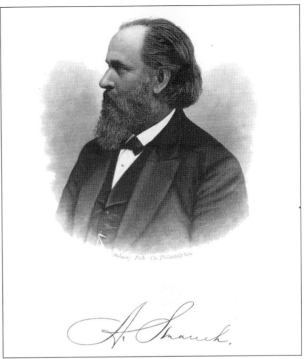

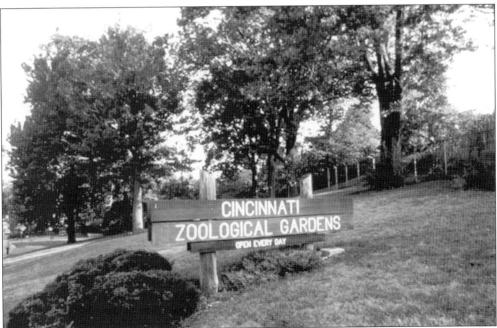

In 1875, the Cincinnati Zoological Garden was opened due to the efforts of prominent businessman Andreas Erkenbrecher. In 1872, a larva was stripping trees of their foliage, thus causing him to organize the Society for the Acclimatization of Birds, which imported thousands of birds from Europe with the hope that they would eliminate the caterpillars plaguing the area. Out of his interest in birds, there arose the idea of establishing a zoo. Located at Vine Street and Erkenbrecher Avenue, it consists of close to 60 acres of land.

Andreas Erkenbrecher came to America in 1836 at age 14 and eventually established a starch factory, which by the 1870s was manufacturing 40,000 pounds annually. Like many German American businessmen, he was devoted to philanthropic and civic endeavors beneficial to Cincinnati. The aim was to contribute to the city in return for the good life that he found here.

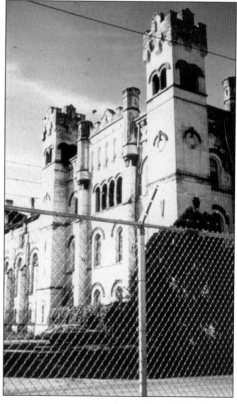

Although no longer standing, the Cincinnati Workhouse, or *Stadtgefängnis*, was erected in 1866–1869 in a park consisting of 26 acres with trees and a water fountain. Built by the firm of Adams and Hannaford, it strongly resembled the Bavarian castle of Hohenschwangau, the home of the so-called "Mad King" Ludwig of Bavaria. Getting sent "to the castle" meant that one was sentenced to do time there.

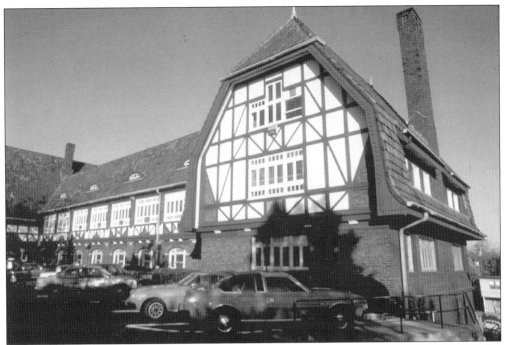

Half-timber, or *Fachwerk*, is a popular German building style found throughout the area. This building, once housing the Gruen Watch Company, is located on East McMillan Street in Walnut Hills and was constructed to resemble an alpine chalet on a landscaped hill surrounded by rock gardens. Built in 1917, it is now the site of the Union Institute and University. German building styles showed a preference not only for half-timber, but for brick as well.

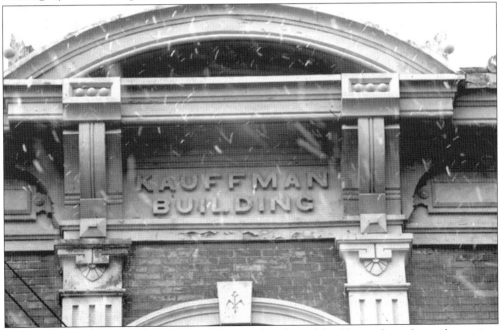

German guild craftsmen skillfully and intricately adorned buildings throughout the region, contributing to the image of the region.

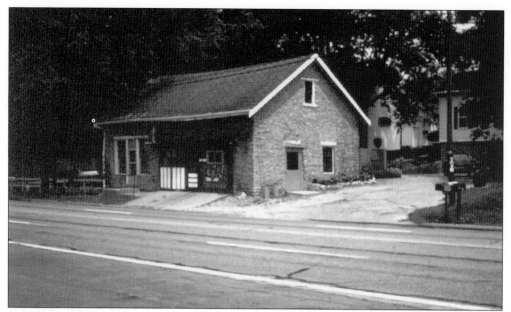

Fieldstone buildings can be found especially in the outer edges of the city, where German farmers cleared the land of stones and then used them to construct homes and other buildings, such as this mid-19th-century building. Located on Harrison Avenue on the west side, it now serves as a garage. Such buildings were made to last.

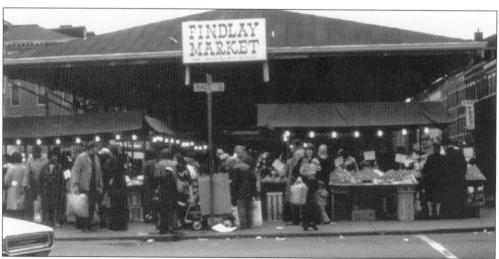

A major landmark, Findlay Market was developed as a German-style market in Over-the-Rhine. Named in honor of Gen. James Findlay, who originally owned the land, the market was completed in 1852, when the district was filled with recently arrived German immigrants. Recently refurbished, it reflects its Old World heritage and is the ideal place to shop for cheese, bread, meat, poultry, and other grocery items. It provides a real flavor of *Zinzinnati* for those interested in tasting it.

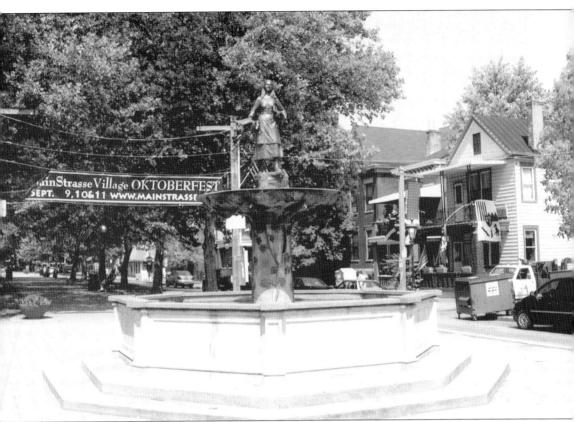

The Goose Girl Fountain, located in the center of the MainStrasse German Village in Covington, was dedicated in 1980. In the Grimm's fairy tale "The Goose Girl," a queen presented her daughter with a magic handkerchief for her journey to be wed to a prince in a distant land. When stopping at a stream to water the horses, the princess dropped her handkerchief in the water, and an evil handmaiden took over the now powerless princess's horse and gown. When they arrived at the castle of the prince, the handmaiden, who assumed the role of princess, sent the real princess to a farmer, saying that she was a goose girl. At the end of each day, the real princess would herd geese and then unbraid her hair and cry. One day, the farmer heard her crying and learned the truth of her identity, whereupon he took her immediately to the king. The prince and the real princess were then married and lived happily ever after, while the imposter princess was imprisoned. German legend and lore thus travel to become part of the area's cultural milieu.

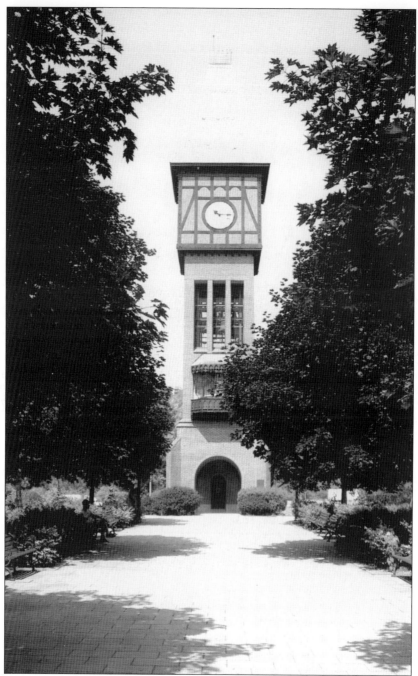

Situated in Covington's MainStrasse German Village, the Glockenspiel has emerged of late as one of the major regional landmarks, alongside the Suspension Bridge and Fountain Square in downtown Cincinnati. The Glockenspiel, in Goebel Park adjacent to Interstate 75, is seen by the thousands who drive past daily. Dedicated in 1979, it was named the Carroll Chimes Bell Tower in honor of then governor of Kentucky Julian Carroll. The German Gothic Glockenspiel plays a 43-bell carillon hourly to present mini-concerts and the lively enactment of the German tale "The Pied Piper of Hamelin."

Two

IMMIGRATION
AND SETTLEMENT

Since Germans have constituted the largest single immigrant group in Greater Cincinnati, it is therefore not surprising that the largest ancestry group in the Cincinnati area today is also German. In the 19th century, German Americans formed districts on both sides of the river, the best known, of course, the historic Over-the-Rhine district. Historian Carl Wittke describes the area as follows:

> Cincinnati's German community, in its early years, was concentrated largely in an area north of where the canal entered the city, and was known as "Over-the-Rhine." Here the Germans lived in neat little frame and brick houses built flush with the sidewalk, and with backyards fenced in with latticework and planted with flower and vegetable gardens. Every Saturday, German housewives scrubbed the front steps of their homes until they were snow white. Here the German *Hausfrau* nourished her family with German food and delicacies, which quickly became part of the American culinary art. After working hours on Sunday, the men sought recreation in the taverns, played euchre, skat, and pinochle, or brought their families to the beer gardens to listen to old German airs.

In the 1780s, the first German settlers arrived in what would become Greater Cincinnati. South of the Ohio River, the first Germans consisted of the family of Johannes Tanner, who in 1785 established Tanner's Station, which later developed into the town of Florence, Kentucky. On the northern side of the Ohio River, Germans were among the first to settle in 1788–1789 in what is now the city of Cincinnati.

More settlers moved west as a result of the Ordinance of 1787, which opened up the vast wilderness region to settlement. Germans were especially attracted to the beautiful Ohio River Valley. By the 1790s, they were settling along the Ohio River, as well as the tributaries feeding into it. Most moved to Fort Washington, which had been established in 1789 to protect settlers from the dangers of the frontier.

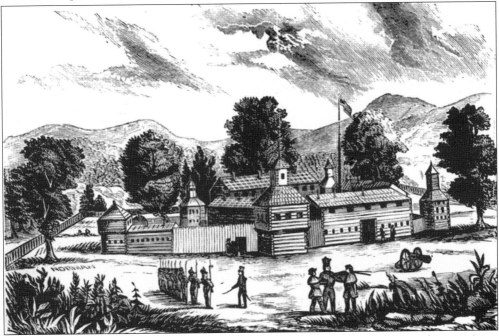

Fort Washington, named in honor of President Washington, served as the United States Army headquarters during the American Indian wars of the 1790s. The site of the fort is noted by a plaque at Third and Broadway Streets in downtown Cincinnati. Stationed here was a Pennsylvania German unit that had served in the American Revolution, and then had been dispatched west to protect the frontier. Many of these Pennsylvania German soldiers eventually settled in the area and attracted friends and family to join them.

Maj. David Ziegler (1748–1811) originally served with Gen. Arthur St. Clair, who was charged with military responsibility for the region, and then later served as commandant at the fort before retiring from military life. Like many other soldiers, Ziegler settled in the area. He opened a store in town and, in 1802, was elected president of the town council and thereby became the first mayor of Cincinnati. Ziegler had served not only in the armies of Frederick the Great of Prussia, but also of Catherine the Great of Russia, before coming to America in 1774.

By means of his agents at the port cities of Baltimore, Philadelphia, and New Orleans, Martin Baum (1761–1831) enlisted recently arrived German immigrants to come to Cincinnati to work in his various businesses, thus making the city a destination. The first genuine self-made man of the West, he founded the Miami Exporting Company, established the first bank, and operated a variety of businesses after coming to the area in 1795.

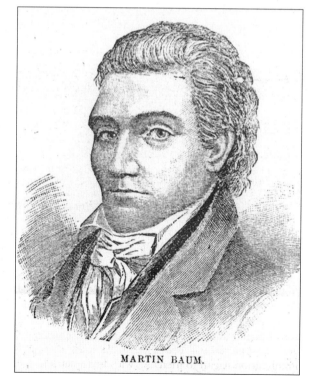

MARTIN BAUM.

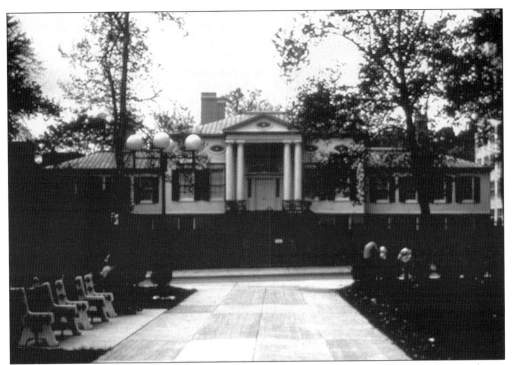

Today, Martin Baum's home is well known as the Taft Museum of Art. Even in Baum's day, it was a center of cultural and literary life, as he helped found the first public library in Cincinnati (1802), the Western Museum (1817), and a literary society (1817). Baum also served as mayor of Cincinnati after Major Ziegler.

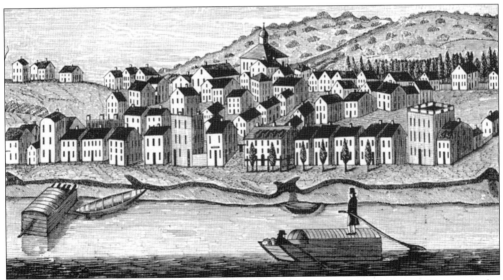

Before 1815, German immigration was nothing more than a trickle, and most Germans who came to the area were either American-born Germans from the eastern states, or pre-American Revolution immigrants. This was due to the upheavals in Europe caused by the French Revolution and the Napoleonic Wars, which basically closed off immigration from Europe. Thereafter, immigration began to increase, with many settlers arriving on keel boats on the Ohio River.

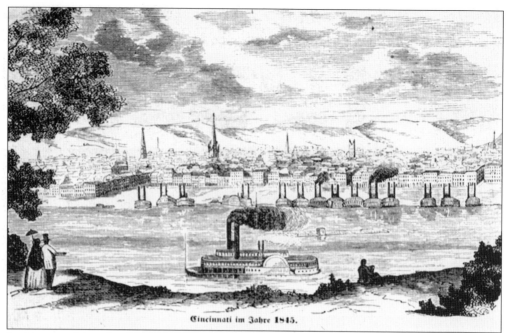

Cincinnati im Jahre 1845.

In the second decade of the 1800s, steamboats were introduced on the Ohio River, and in 1811, Martin Baum's barge, the *Cincinnati*, broke the speed record with a trip from Cincinnati to New Orleans and back in 65 days. It was the steamboat that really contributed to the population growth of the area, as settlers could now travel not only downstream on the Ohio, but also to New Orleans and then upstream on the Mississippi and Ohio Rivers.

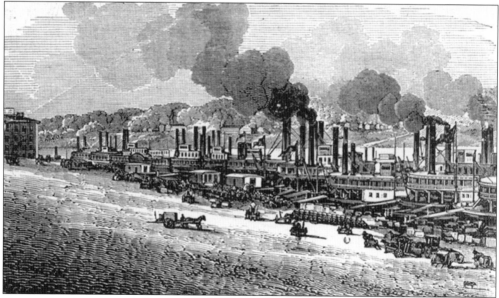

German immigrants arrived on a weekly basis at the riverboat landing in Cincinnati. Although only comprising about five percent of the population before 1815, by 1850, the German-born population had soared to 30,758 out of a total population of 115,436. By 1870, one-third of the population of the city of Cincinnati was of German stock (i.e. either German-born or of German parentage), and this percentage would again increase by the end of the 19th century.

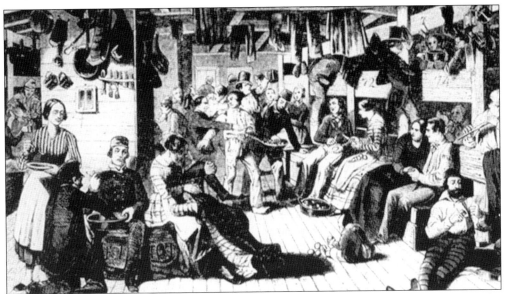

German immigrants made the ocean voyage in steerage, or *Zwischendeck*, which was below the main deck and above the cargo holdings of a ship. Sailing vessels usually took from 30 to 90 days to make the trip. Later in the 19th century, they were replaced by steamers, which arrived in just two weeks.

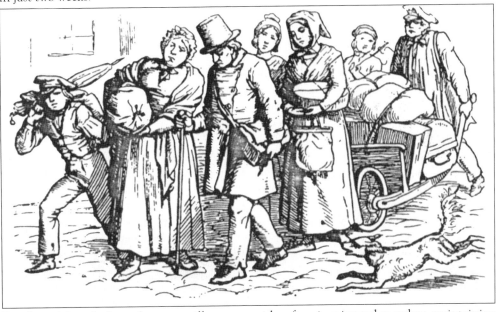

Family and friends from the same village, or parish, often immigrated together, maintaining a group that shared the same customs, traditions, and spoke the same dialect. After settling together in the New World, they usually wrote to relatives and friends in the Old Country, encouraging them to also come to America. This began the process known as chain migration, whereby immigrants from a particular area would come to a spot in America where they had connections. This process would connect Cincinnati to specific places and regions in the German-speaking realm of Europe, especially in the north- and southwestern regions, as well as in the former provinces of Austria-Hungary.

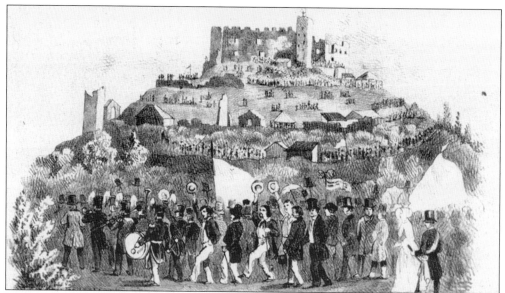

Thousands of craftsmen, students, farmers, officials, and young intellectuals gathered at the ruins of the castle of Hambach in Germany to listen to speeches on liberty, reform, and the tyranny of the German princes in May 1832. The gathering resulted in arrests, censorship, and other oppressive measures, causing many so-called "Thirtyers" to immigrate to America. Among them were Heinrich Roedter, who came to Cincinnati and edited the *Volksblatt*, and Carl Reemelin, who was elected to the Ohio State Legislature.

In 1848, a major revolution swept across the face of Europe with the goal of creating a united states of Germany under a republican form of government modeled on the American constitution. After it failed, thousands of so-called "Forty-Eighters" immigrated to America. German-American historian Rudolf Cronau assesses their importance, "While the former German immigration had consisted essentially of farmers, workmen, and traders, now scholars and students of every branch of science, artists, writers, journalists, lawyers, ministers, teachers, and foresters came in number." The Forty-Eighters quickly emerged as leading voices in the German American community and were particularly active in the press and in politics.

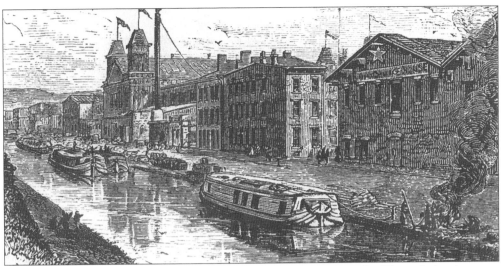

Germans first congregated in a section of Cincinnati known as Over-the-Rhine. Its borders were defined by the Miami-Erie Canal (now the Central Parkway) on the west and south, completed in 1831, and McMicken and Reading Avenues on the north and east. The old barge canal was dubbed "the Rhine," as when one crossed over it one entered the German district.

Over-the-Rhine was described by D. J. Kenny as the district in which "everything is German and even the American discards his formality and envelops himself in German Gemütlichkeit." Here were German restaurants, bakeries, open-air markets, beer gardens, theaters, and newspapers. People lived in narrow brick or frame houses built flush with the street, with backyards fenced in with flower and vegetable gardens. Sidewalks were mopped and scrubbed, and children played mainly in Washington Park or on school grounds. Weekends found many families relaxing in the neighborhood beer gardens located throughout Over-the-Rhine.

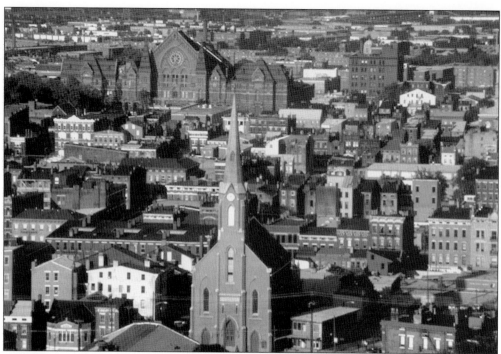

Over-the-Rhine actually consisted of a number of sub-districts, as most Germans lived next to the church of their particular denomination. It was a densely populated area, with estimates running over 75,000 inhabitants during the 19th century.

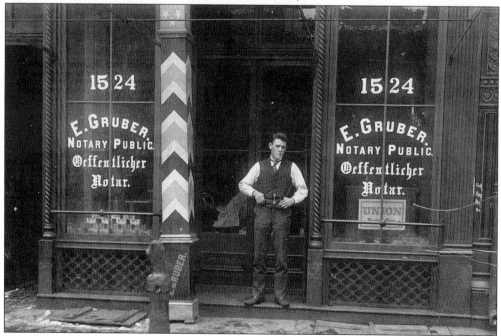

The district was filled with German shops and stores with German signs and provided all that one needed in terms of goods and services. Moreover, it was a place where one felt at home and was also referred to as "Little Germany," or *Kleindeutschland*.

The wealthy did not live in Over-the-Rhine, but rather to the west of the district. The West End's Dayton Street was known as "Beer Baron's Row." The house in the center of this image was the residence of Johann Hauck, founder of the Hauck Brewing Company. Located at 812 Dayton Street, it now serves as the Hauck House Museum, providing an excellent example of the home life of a prominent German American brewing family.

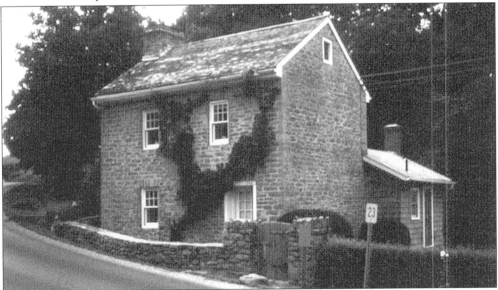

Not all Germans gravitated to the central city area. In 1795–1796, Christian Waldschmidt and a group of Pennsylvania Germans settled on the East Side of Cincinnati in what is now known as Camp Dennison. They called their settlement Germany and erected a sawmill there. They constructed fieldstone buildings that resemble those in Pennsylvania. The stone structure depicted here is the c. 1804 Kugler House, which Waldschmidt built for his daughter and her husband, Mathias Kugler. After Waldschmidt's death in 1814, Kugler continued the operation of the mill. The site of the village at 7509 Glendale-Milford Road now features the Waldschmidt House Museum.

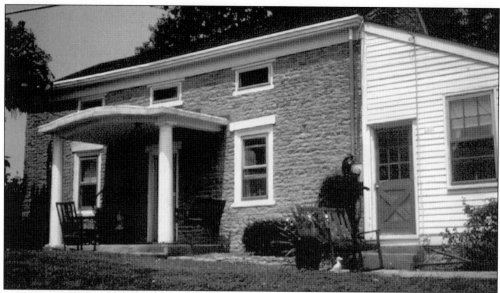

On the West Side of Cincinnati, Germans were also settling down and building fieldstone houses. Most of these homes are located in Colerain and Green Township and were built in the 1850s and 1860s. They are usually one-and-a-half stories high and one room deep with a low-pitched gable roof. Germans also built a wide variety of buildings, including stone barns, creameries, summer kitchens, and even distilleries. Some, like the one depicted here, have recently been refurbished with all the modern-day conveniences.

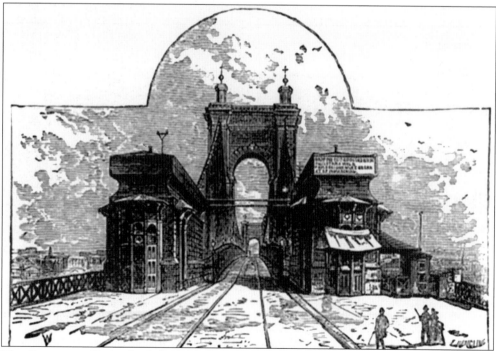

The Suspension Bridge built by Johann A. Roebling provided a direct connecting link to northern Kentucky, where the German element was rapidly expanding in Covington and Newport in the late 19th century.

Elizabeth Petuchowski describes how she and her husband, Jacob Petuchowski, came to Cincinnati after World War II as part of the German Jewish immigration to the area. Her essay, "New to America/New to Cincinnati," appeared in the *Max Kade Occasional Papers in German-American Studies*, published by the German-American Studies Program of the University of Cincinnati.

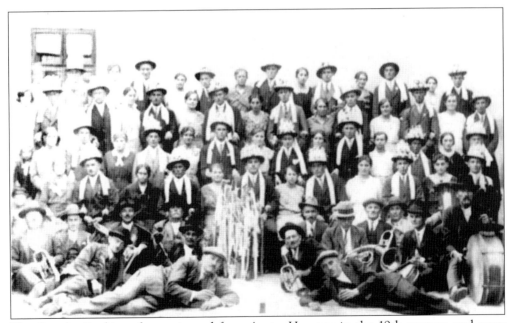

The Danube Swabians first emigrated from Austro-Hungary in the 19th century, and more came following dissolution of the Habsburg Empire after World War I. However, the greatest immigration wave came after World War II as a result of the expulsion of ethnic Germans from their homelands.

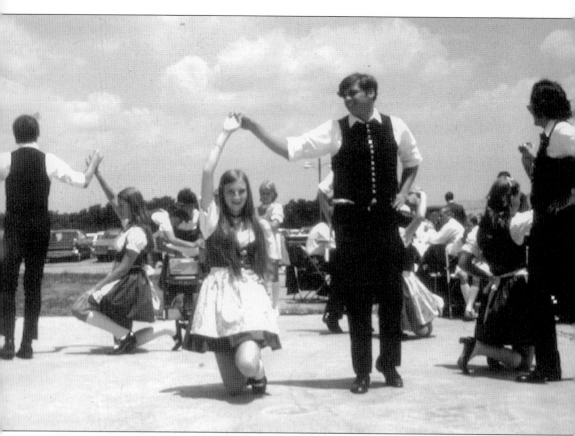

The Danube Swabians founded the *Verein der Donauschwaben*, which celebrated its 50th anniversary in 2004.

Manfred Schnetzer was one of the many German immigrants who arrived in Cincinnati with his family in the 1950s. He became an active member of the Kolping Society as well as the German-American Citizens League of Greater Cincinnati.

Deutsche Einwanderung in die Vereinigten Staaten seit 1820

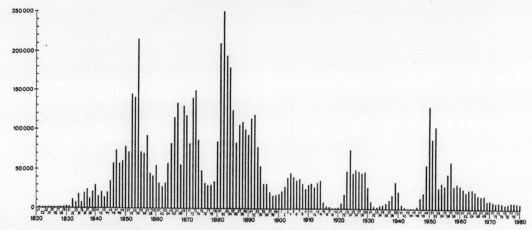

Quelle: Zusammengestellt nach United States, Bureau of the Census, **Historical
Statistics of the United States: Colonial Times to 1970** (Washington, D. C.),
Serien C 89-119 und dem jährlichen **Statistical Abstract of the United States**
seit 1971

Graphik:
Dr. H.-J. Kämmer

German immigration has ebbed and flowed in accordance with the social, political, and economic factors in European and American history and is best traced by means of this chart, which documents the highs and lows. Although it fluctuates with these factors, immigration never entirely ceases, but is rather an ongoing dimension. German immigrants and their descendants successfully transplanted their Old World culture to Greater Cincinnati and laid the foundations for what we know today as the region's German heritage.

Three

RELIGIOUS LIFE

Religious life emerged from German Protestant, Catholic, and Jewish institutions and organizations founded in the 19th century, including churches, temples, hospitals, orphanages, nursing homes, seminaries, and schools. Faith and heritage were often intertwined, with many stressing the importance of the German language and heritage for religious worship and education. Even today, German church services and masses are available in the area, and many congregations sponsor German-style dinners and festivals throughout the year. German American churches populate the cityscape, and many, of course, have German inscriptions and are also filled with the paintings, wood carvings, and sculptures of German American artists. Some of them issued newspapers or journals that provide valuable historical information on the area.

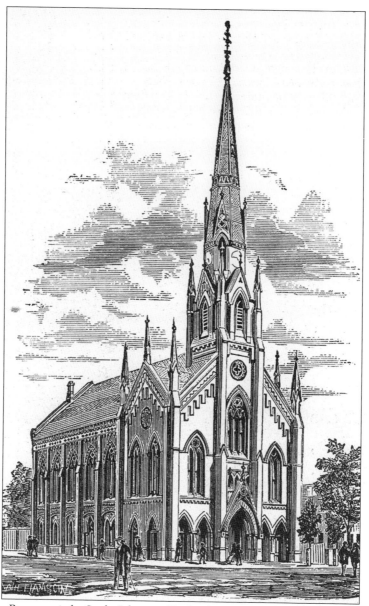

The *Deutsche Protestantische Sankt Johannes Kirche*, located at the corner of Twelfth and Elm Streets in Over-the-Rhine, was built in 1867, but its roots go back to the first German congregation in Cincinnati, the German Evangelical Lutheran and Reformed Church, formed in 1814. In 1838, North Germans withdrew to form the North German Lutheran Church due to regional and dialectal differences between those from northern and those from southern Germany, with the former stressing the use of Low German and the latter High German. In 1841, Rev. August Kröll, a liberal-minded graduate of the Rationalist University of Giessen, arrived in Cincinnati and became the pastor of Sankt Johannes, a position he held until his retirement in 1874. He brought stability and unity to the other German Protestant congregations in the area. In 1849, he established a German Protestant newspaper, *Die Protestantischen Zeitblätter*, to encourage the goal of German Protestant unity. Today, the congregation lives on as St. John's Unitarian Church in Clifton, but its majestic 19th-century edifice still stands in Over-the-Rhine.

In 1894, the First German Evangelical Protestant Church, located on Hoffner Street, was dedicated. This church, which served the German Protestants of Cumminsville, no longer stands, but the congregation continues in its new church, the First United Church of Christ at 5808 Glenview Avenue. Many of the stained-glass windows from the old church were installed in this new building, which celebrated the congregation's 150th anniversary in 2005.

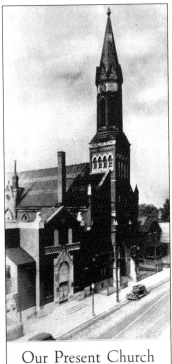

Our Present Church
1945

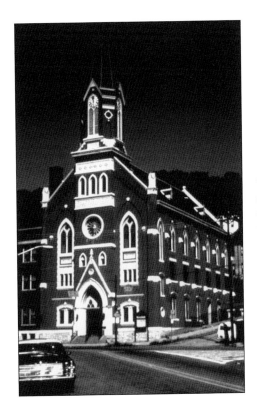

The Philippus United Church of Christ, located at 106 West McMicken Avenue in Over-the-Rhine, was founded in 1890, and its red brick Gothic Revival building was dedicated in 1891. In 1968, the church created a war memorial of a World War I United States Army helmet on the cross above its entrance, thus honoring the military service of its parishioners during a war noted for its anti-German sentiment. Filled with stained-glass windows, Philippus includes a majestic organ donated by beer baron Christian Moerlein, whose brewery was located nearby. The church is noted for the gilded hand atop its steeple, which points heavenward for all to see.

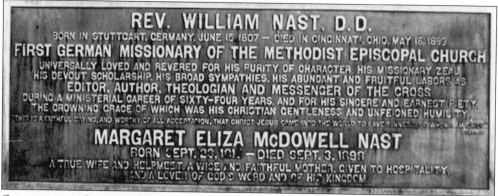

REV. WILLIAM NAST. D.D.
BORN IN STUTTGART, GERMANY, JUNE 15, 1807 — DIED IN CINCINNATI, OHIO, MAY 16, 1899

FIRST GERMAN MISSIONARY OF THE METHODIST EPISCOPAL CHURCH

UNIVERSALLY LOVED AND REVERED FOR HIS PURITY OF CHARACTER, HIS MISSIONARY ZEAL
HIS DEVOUT SCHOLARSHIP, HIS BROAD SYMPATHIES, HIS ABUNDANT AND FRUITFUL LABORS AS
EDITOR, AUTHOR, THEOLOGIAN AND MESSENGER OF THE CROSS
DURING A MINISTERIAL CAREER OF SIXTY-FOUR YEARS, AND FOR HIS SINCERE AND EARNEST PIETY,
THE CROWNING GRACE OF WHICH WAS HIS CHRISTIAN GENTLENESS AND UNFEIGNED HUMILITY.
THIS IS A FAITHFUL SAYING, AND WORTHY OF ALL ACCEPTATION, THAT CHRIST JESUS CAME INTO THE WORLD TO SAVE SINNERS, OF WHOM I AM CHIEF.

MARGARET ELIZA McDOWELL NAST
BORN SEPT. 23, 1811 — DIED SEPT. 3, 1899

A TRUE WIFE AND HELPMEET, A WISE AND FAITHFUL MOTHER, GIVEN TO HOSPITALITY,
AND A LOVER OF GOD'S WORD AND OF HIS KINGDOM.

Originating in Cincinnati, German Methodism is associated with the work of Rev. Wilhelm Nast, who came to America after studies at the University of Tübingen. Sent to Cincinnati as a German Methodist missionary, Nast became the founding father of German Methodism and also the German Methodist newspaper *Der Christliche Apologete*, which commenced publication in 1838. By the time of World War I, six German Methodist churches stood in Cincinnati, as well as several in northern Kentucky.

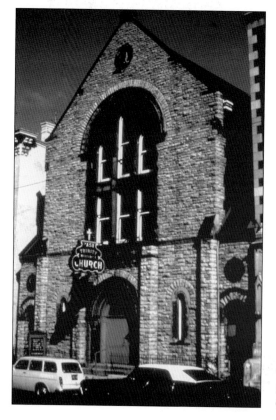

The mother church of German Methodism stands on Race Street in the Over-the-Rhine district.

German Methodists built impressive church edifices in the Gothic Revival style.

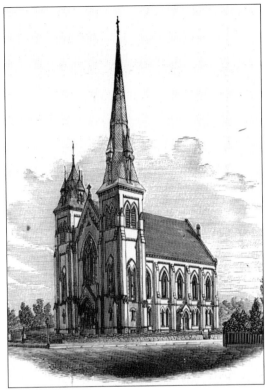

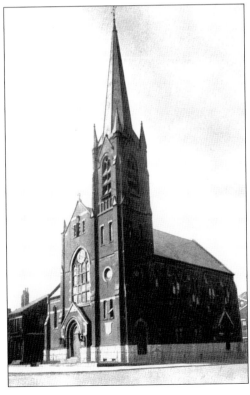

The Salem German Methodist Church in Newport, Kentucky, represents a typical German Methodist building in the Greater Cincinnati area.

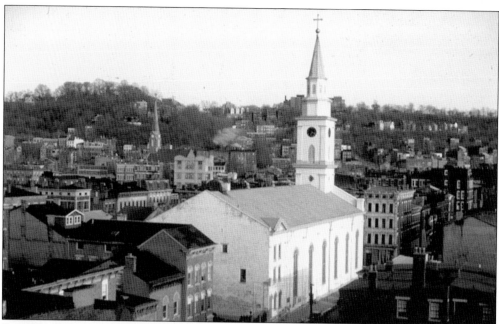

By 1870, there were 49,960 German Catholics in Cincinnati—no doubt the largest of all the religious denominations in the area. Old St. Mary's Church was built in 1842 at Thirteenth and Clay Streets in Over-the-Rhine to serve the needs of the rapidly growing German Catholic population. The unique church is built of bricks that were homemade and baked in parishioners' ovens and then brought to this site. Recently refurbished, the church features beautiful stained-glass windows bearing the names of their donors.

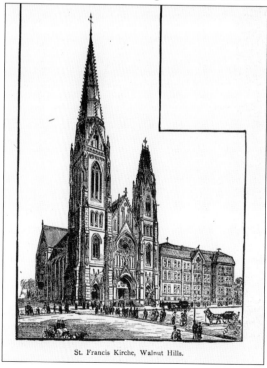

St. Francis Kirche, Walnut Hills.

St. Francis Church is located in Walnut Hills.

St. George's Church stands on Calhoun Street, adjacent to the University of Cincinnati.

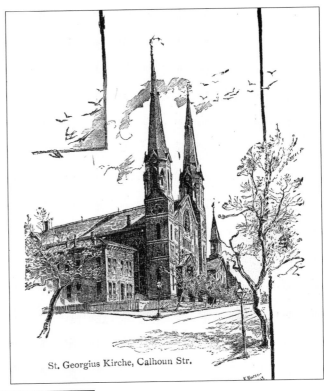

St. Georgius Kirche, Calhoun Str.

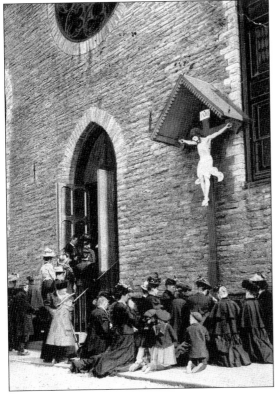

Holy Cross–Immaculata Roman Catholic Church, at 30 Guido Street in Mount Adams, is well-known as the "Church of the Steps," and is constructed of stone from the area's slopes. Since 1860, it has been the site of the annual Good Friday Pilgrimage in which the devout say prayers on each step up to the summit. Johann Schmitt, who also created the murals for the Mutter Gottes Kirche in Covington, painted the interior murals, some of the finest in the region.

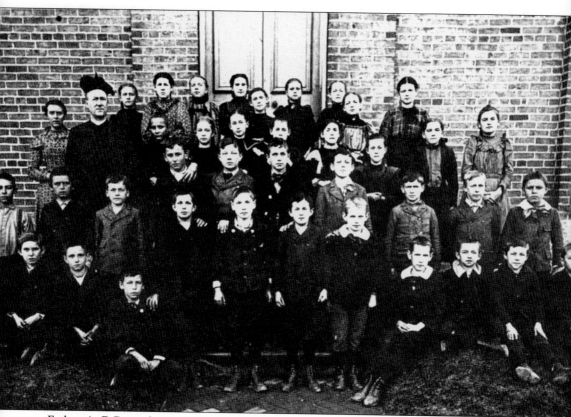

Father A. F. Runnebaum and students stand in front of the original St. Aloysius-on-the-Ohio after its renovation into a school, around 1900.

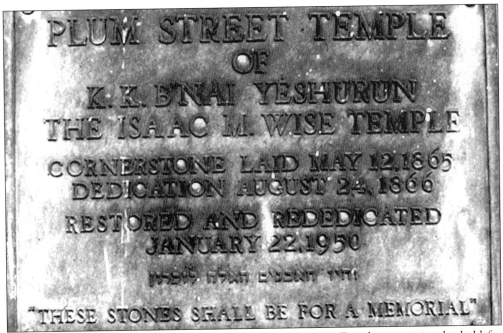

PLUM STREET TEMPLE
OF
K. K. B'NAI YESHURUN
THE ISAAC M. WISE TEMPLE
CORNERSTONE LAID MAY 12, 1865
DEDICATION AUGUST 24, 1866
RESTORED AND REDEDICATED
JANUARY 22, 1950

"THESE STONES SHALL BE FOR A MEMORIAL"

In 1854, Isaac Mayer Wise became rabbi of the Plum Street Temple, a position he held for 46 years, and founded the *Israelite* newspaper, along with its German-language supplement, *Die Deborah*. He also worked for the establishment of Hebrew Union College and the union of American Hebrew Congregations in 1873. By the time of World War I, 17 German Jewish congregations existed in Cincinnati, the new center for Reform Judaism.

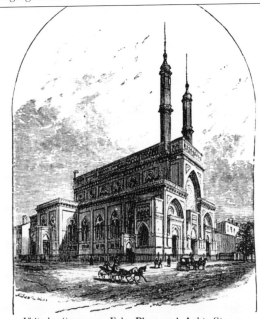

Jüdische Synagoge, Ecke Plum und Achte Strasse.

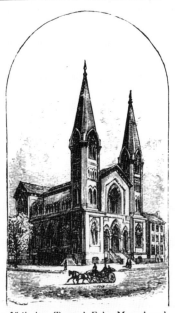

Jüdischer Tempel, Ecke Mound und Achte Strasse.

This view shows the Plum Street Temple, on the left, and the temple on the corner of Eighth and Mound Streets, on the right.

CONCORDIA KIRCHE

– LUTHERISCH –

Central Parkway & Clifton Hills

Deutscher Gottesdienst sonntaglich 9:00 Uhr
Jesus – der Weg, die Wahrheit, das Leben.
Arthur L. Scheidt, Pastor

861 - 9552 or 481 - 9633

ST. MARIENKIRCHE

– KATHOLISCH –

13th and Clay Street

Deutsche Singmesse jeden Sonntag um 11 Uhr
Lateinische Messe jeden Sonntag um 12:30 Uhr
Beichtgelegenheit: Sonntag von der 11 Uhr Messe
An Wochentagen Eingang Seitentür
Klingel am Beichtstuhl

German masses are held weekly at Old St. Mary's in Over-the-Rhine. Many Catholic churches sponsor German-style festivals throughout the summer months, as do German American churches of other denominations. J. D. Kenny writes of German American religious life, "There is a deep vein of religion in the innermost recesses of the German nature. The purest and most elevated sentiments are the most loudly applauded. . . . They have many churches, whose steeples and spires rise one above the other."

Church of the Lutheran Hour

Concordia

"MISSOURI SYNOD"

SERVICES 8:00 A.M. & 11 A.M.
GERMAN 9:00 A.M.
CHURCH SCHOOL 9:45 A.M.
Harry D. Smith, *pastor* 922·4177

German services are also held at the Concordia Lutheran Church. This sign dates to the 1980s, when Reverend Smith served as the congregation's pastor. Originally located in the Over-the-Rhine district, Concordia traces its roots back to the Holy Trinity Lutheran Church, founded in 1849, and belongs to the Lutheran Church–Missouri Synod, which is headquartered in St. Louis. In addition, Concordia offers an elementary school and has most recently constructed a hall for social activities and meetings.

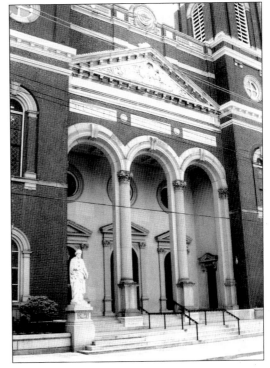

The German Catholic *Mutter Gottes Kirche*, or Mother of God Church, was built at 119 West Sixth Street in 1842 with funds from the Leopoldine Society of Vienna. Considered one of the most beautiful German American churches in Greater Cincinnati, it contains five murals by the well-known German American artist Johann Schmitt. Its stained-glass windows were imported from Munich, as were the two stone statues of Saints Peter and Paul and the two mythological lions at the church entrance. Other German American artists completed the frescoes, sculptures, and the Stations of the Cross within the church.

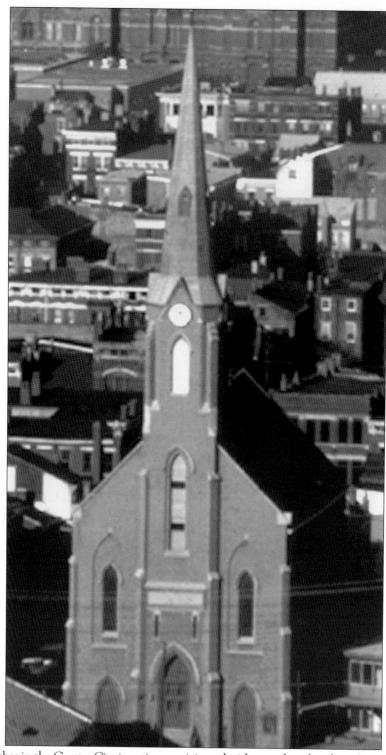

Most churches in the Greater Cincinnati area originated with a mother church in Over-the-Rhine.

Four

SOCIAL LIFE

German Americans greatly influenced the growth and development of American social life. German customs, traditions, and values derived from the basic unit of the family and found further expression in the community at large by means of the many festivities and functions sponsored by German American societies and churches. An examination of the annual social calendar of the area reveals that from June through Labor Day approximately 150 festivals occur, with slightly more than half sponsored by churches, the rest by area societies. German American social life was also reflected before Prohibition in the many cafés, restaurants, beer gardens, and halls throughout the area and continues to find expression in more recently established venues popular with Cincinnatians and tourists alike.

German beer gardens, cafés, and restaurants were places for the entire family. Stephen Z. Starr writes the following: "One cannot help but be impressed by the decency and good order with which so many of these places, particularly the saloons in the Over-the-Rhine area, were conducted. People came to them to drink, to be sure, but they drank for conviviality, not for excess. And it should not be forgotten that while many forms of entertainment of our own day keep us apart, the neighborhood saloon, with its bar, its sitting room, its garden, and its glasses of mild beer for a nickel, brought people together, and gave them a sense of belonging, of being part of a community."

D. J. Kenny's *Illustrated Cincinnati* (1875) describes the "sausage man" as a popular figure in German American beer gardens and saloons in Over-the-Rhine. Kenny notes the following: "The sausage man perambulates them at all hours of the day and evening; but chiefly at half-past nine and eleven in the morning; about six in the evening, and throughout the evening, from seven or eight till after midnight. He is persistent, but not half so insolent as the London itinerant vendor."

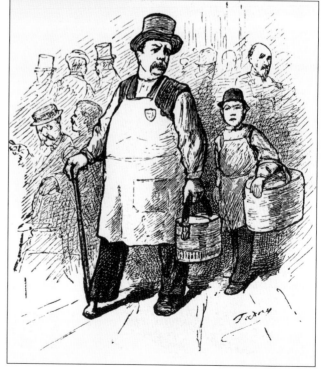

According to D. J. Kenny, a waiter was "above all things a man to be pitied, and a man to be admired. To be pitied, because he seems to be perpetually on those not very fat legs of his with never a moment's time for a private dive into one of those glasses he hands about to his thirsty patrons literally by the hundred. He often brings them by the ten or a dozen in each hand. He is to be admired for his imperturbable good nature, for his freedom from flurry, his constant sobriety, and that prompt memory which rarely, if ever makes a mistake in the precise number of beers, mineral waters, or glasses of wine ordered, or the exact table to which they are to be brought. He is a capital fellow, and probably 'takes his' in the afternoon before his night work commences."

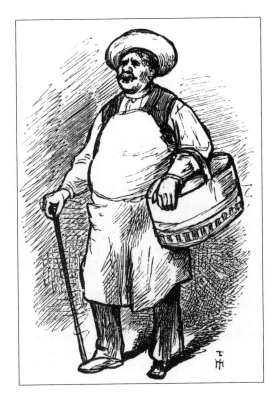

The wienerwurst man was "another well-known character 'Over-the-Rhine.' He is constantly to be met with, and is known by everybody. He carries with him a large tin full of sausages, while a small boy by his side bears the bread, the salt, and the pepper."

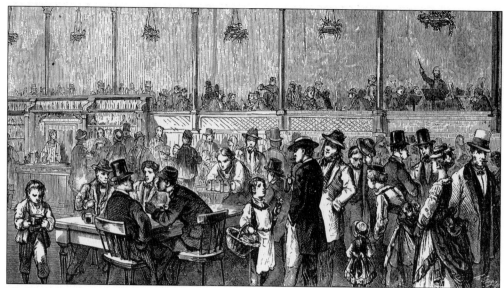

Wielert's Pavilion, located at 1408–1410 Vine Street in Over-the-Rhine, consisted of not only a saloon, but also a concert hall and beer garden, and was one of the most popular places of its kind before Prohibition. Most importantly, it stood on Vine Street, which bisected the district and is to this day considered the dividing line between the East and West Sides of Cincinnati. Before Prohibition, it was the street with the greatest concentration of saloons in Cincinnati with a grand total of 136.

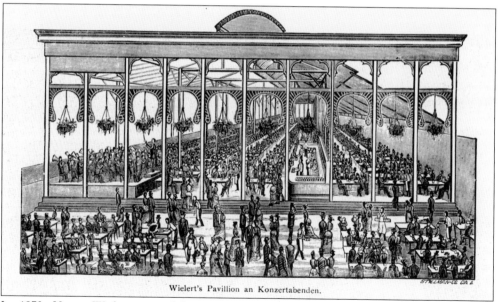

Wielert's Pavillion an Konzertabenden.

In 1873, Henry Wielert opened his popular establishment, which became the unofficial headquarters of Cincinnati's Republican machine run by "Boss" George B. Cox, with the able assistance of his German American assistants Rudolph Hynicka and August Herrmann. As a rule, if a patron did not look at the menu to place an order at Wielert's, the waiter would bring out the standard order—Wiener Schnitzel, German fried potatoes, rye bread, and beer. Local music groups, such as Michael Brand's Cincinnati Orchestra Reed Band, provided entertainment, which added to the *Gemütlichkeit*.

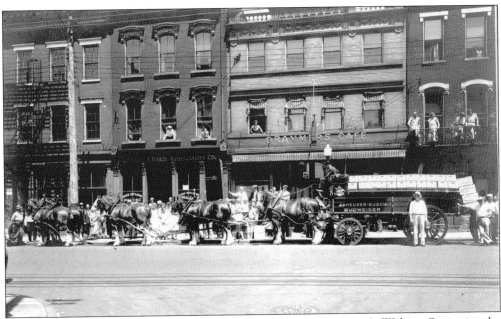

In 1872, Anton Grammar opened Grammer's Restaurant at 1440 Walnut Street in the Over-the-Rhine district, and it became well known for its fine food and beverages.

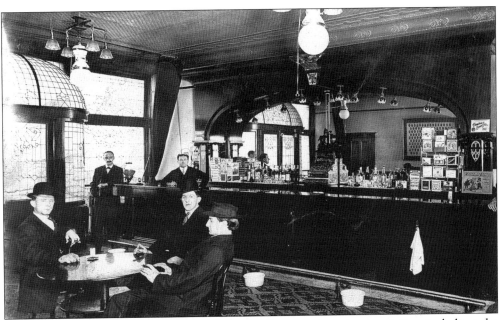

Grammer's also served as a meeting place for German American societies, including the *Bäcker-Gesangverein* and the German Literary Club, and its second-floor meeting rooms contain many historic photographs of these groups. Grammer's remains open today, but only for private parties.

In 1865, Louis Mecklenburg opened Mecklenburg Gardens. Located several blocks east of the University of Cincinnati in Corryville, it is the only pre-Prohibition beer garden in operation today in Greater Cincinnati.

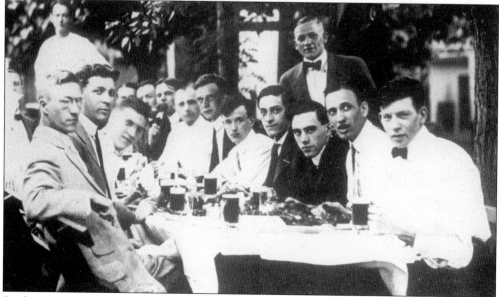

Students from the University of Cincinnati pose in Mecklenburg Gardens.

Reichrath's Park was one of the many popular German American beer gardens.

Many families spent their Sunday afternoons in one of the area's beer gardens.

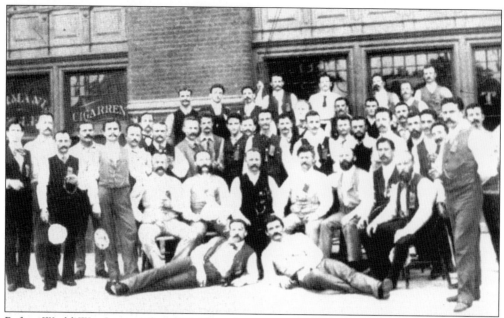

Before World War I, more than 100 German societies, or *Vereine*, operated in the area. They sponsored a wide variety of festivities, ranging from *Maifest* to *Schützenfest*. These German societies were affiliated with the German-American Alliance of Cincinnati, which sponsored the annual German Day. Covington and Newport also had similar umbrella organizations planning German Day festivities, which, like the Cincinnati alliance, were affiliates of the National German-American Alliance.

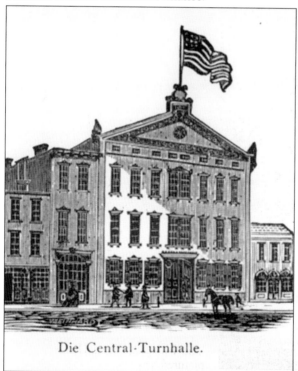

Die Central-Turnhalle.

Founded in 1848 by Friedrich Hecker and other Forty-Eighters, the Cincinnati Turnverein was not only the oldest, but also the largest and most influential German American society. Although some societies maintained their own clubhouses, many of them met at Turner Hall, located at 1409–1413 Walnut Street in Over-the-Rhine. A local German American history describes its hall as "a mighty fortress of German-American culture," as it served as the central German American social, cultural, and political center. The following could be found at Turner Hall: art classes, physical education courses, a library, the German Theater, and musical programs presented by German bands and choirs. The politically active Turners strongly supported German instruction and physical education in the public schools.

Covington's Turner Hall, located at 447 Pike Street, was built in 1877, but the society itself was founded in 1855. The Turnverein includes a women's auxiliary and a youth club and has sponsored basketball and baseball teams.

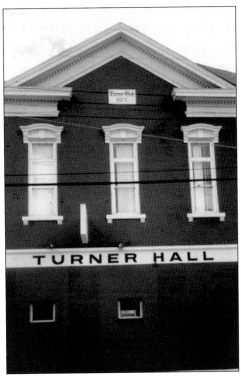

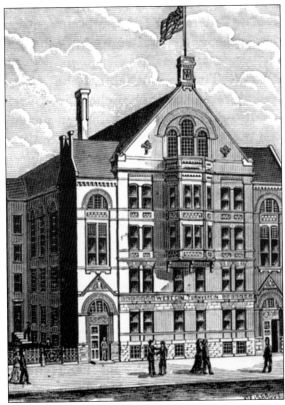

The West End Turner Hall is pictured here.

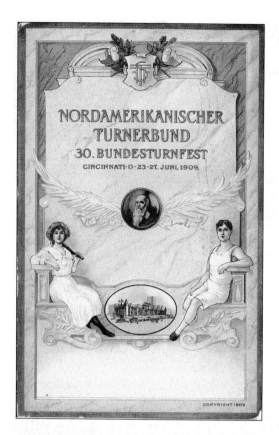

The national *Turnfest*, sponsored by the National Federation of Turner Societies, was held in Cincinnati in 1909.

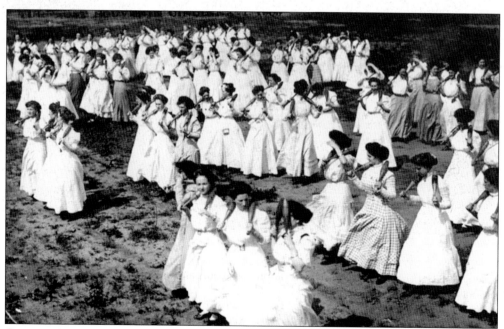

German American women took an active role in the Turner societies, participating in the performances for the *Turnfest*.

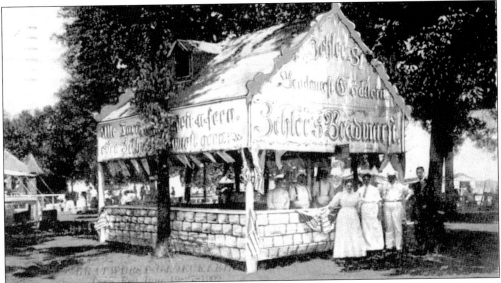

No German-style festival is complete without a Bratwurst stand.

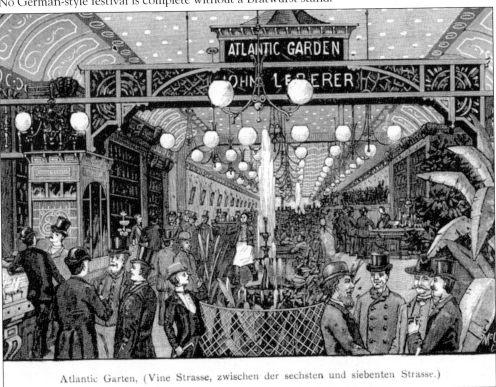

Atlantic Garten, (Vine Strasse, zwischen der sechsten und siebenten Strasse.)

Aside from the German-American celebrations, one could always frequent the many beer gardens, saloons, and restaurants, such as Hildebrand's, Schuler's, Kissel's, and Schwenberger's. All of them provided good beverage as well as good German food—Wurst, Sauerbraten, Hasenpfeffer, Schnitzel, and if desired, even an American-style beefsteak. At 5¢ a mug, beer was common, and some places advertised 21 beers for $1, even adding a Wienerwurst with each drink. Saloon signs often promoted the "Largest Glass of Beer in the City for a Nickel."

Many establishments also practiced the "free-lunch tradition" to draw in clientele and whet their thirst. This consisted of tables piled high with wurst, ham, roast beef, herring, cheese, pickles, radishes, pretzels, crackers, and breads of all kinds.

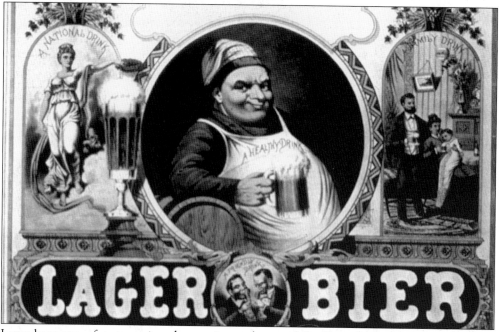

Lager beer was, of course, viewed as an integral part of the German diet, but it was also an essential element of German social life. Try to imagine a German-style festival without the brew, for example. The process of brewing lager emerged in the early 19th century. A lighter-bodied and more sparkling beverage, lager came to America and Cincinnati with the German immigration, and the number of breweries grew accordingly—from 8 in 1840 to 36 by 1860. Almost half the beer brewed in Cincinnati was exported, but the rest was consumed in the region. Before World War I, the per capita consumption of beer nationally stood at 16 gallons, but in Cincinnati it was at 40 gallons, or more than twice the national average. An 1863–1864 chamber of commerce report states, "A large number of citizens would dispense with their bread rather than their beer."

A welcome person in local beer gardens and halls was the barmaid, and contests were held to see how many beer steins she could hold. German-style beer gardens were scattered throughout Over-the-Rhine. According to D. J. Kenny, "The air streams through the lattice-work at either end of the gardens and gently bends through the tops of the trees shading the tables or toys with the oleander blossoms fluttering over the dark green foliage or the darker bark of the trunk and branches. Many of the gardens are ornamented with portraits, generally of Beethoven, Schubert, Mozart, Carl Maria von Weber, Mendelssohn, Schumann, or other great musicians, and in all the great ones there is an orchestra. The best music worthily rendered is alone listened to with any degree of attention, and when a noble masterpiece is given with effect the delight of the listeners is keenly felt and warmly expressed."

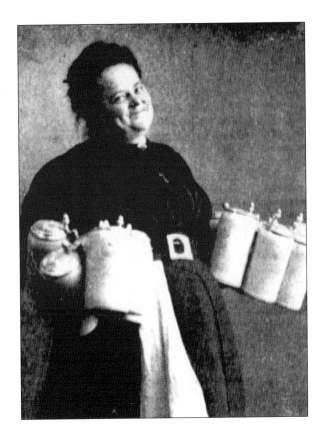

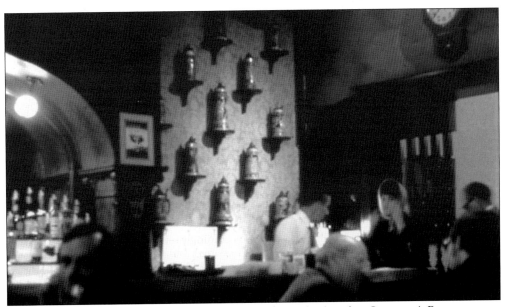

Likely the best local collection of antique beer steins can be found at Grammer's Restaurant.

A hot bird, a pretty maid and a cold stein,
Makes Life worth living, all of the time.

Given the Noah's flood of beer emanating from the region, a number of stereotypes emerged about German Americans and their favorite beverage. These were depicted in postcards of the era.

"Enough is enough, and sometimes plenty"
To everyone is clear,
But it don't refer to a German,
When he's drinking Lager beer.

Such postcards were popular in the pre-Prohibition era.

Five

EDUCATION

German was introduced in the public school system of Cincinnati in 1840, which thereby became the first in the country to offer bilingual instruction. At its height, the German program had 250 teachers and close to 20,000 students. German instruction was also available in the area's private and parochial schools.

The state law banning German from public, private, and parochial schools below the eighth grade, a direct result of the anti-German hysteria of World War I, was declared unconstitutional in 1923 by the United States Supreme Court. German thrived in the school curriculum at the secondary level, but it was not reintroduced at the elementary school level until 1974, with the opening of the Fairview German Language School. Today, German is offered by the area's secondary schools, as well as some of the German American societies such as the Tri-State German-American School Society. German has also been offered at area colleges and universities since the 19th century, and libraries like the Cincinnati Public Library and the Blegen Library at the University of Cincinnati have built strong collections of German materials.

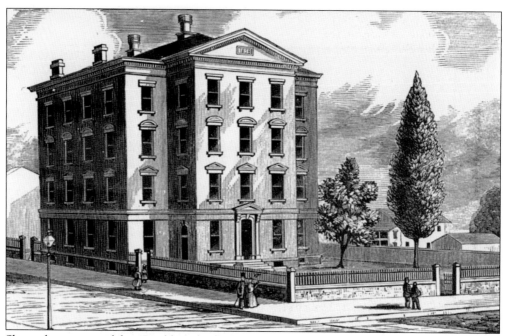

Shown here is one of the 47 public schools in Cincinnati that offered German instruction prior to World War I. The German bilingual program, founded in 1840, was the first offered by a public school system in the country. German classes usually ran for 90 minutes daily.

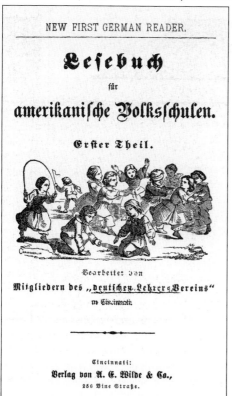

NEW FIRST GERMAN READER.

Lesebuch

für

amerikanische Volksschulen.

Erster Theil.

Bearbeitet von

Mitgliedern des „deutschen Lehrer-Vereins"

in Cincinnati.

Cincinnati:

Verlag von A. E. Wilde & Co.,

250 Vine Straße.

Das Amerikanische A-B-C Buch was one of the many German American books used in the public schools. These texts aimed to teach German not as a foreign language, but rather a heritage language, and provided readings dealing not only with Germany, but also with German American and American topics.

The American Book Company printed many of the textbooks used in the public schools regionally as well as nationally.

Die besten

Deutschen Textbücher

für

Elementarschulen, Hochschulen und Kollegien

Wir haben ein reichhaltiges Lager von Fibeln, Lesebüchern, Grammatiken und zahlreichen Werken der modernen Schriftsteller und der Klassiker zu sehr mäßigen Preisen. -:- -:- -:-

Lehrer des Deutschen und sonst alle, welche sich dafür interessieren, werden gebeten, um unseren Katalog deutscher Bücher an uns zu schreiben

American Book Company

300 Pike Strasse, . . Cincinnati, Ohio

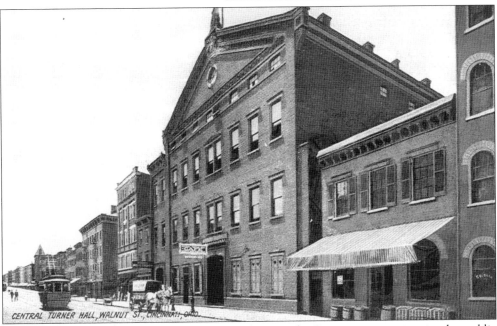

CENTRAL TURNER HALL, WALNUT ST., CINCINNATI, OHIO.

The Cincinnati Turnverein actively promoted not only German instruction in the public schools, but physical education as well. In 1860, the Cincinnati School Board resolved to make gymnastics a part of the school curriculum and, in 1892, appointed a superintendent of physical culture. In 1893, the first major gymnasiums were opened at Woodward and Hughes High Schools.

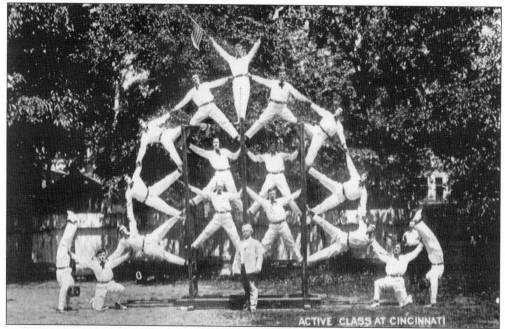

Turners stressed the importance of a "sound body and a sound mind."

Dr. H. H. Fick served as superintendent of the German Department of the Cincinnati Public Schools before World War I. At that time, almost 20,000 students were enrolled in the German program, which employed more than 250 teachers. In addition, Dr. Fick edited an educational journal for children, *Jung-Amerika*, and published a series of textbooks for use in German bilingual programs.

The St. Joseph of Nazareth Roman Catholic Church, located at 220 West Liberty Street, offered German instruction, as did other German American churches across the region.

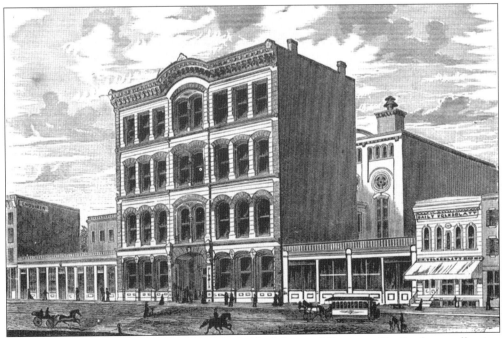

Due to the substantial German element, the Public Library of Cincinnati built a large collection of German materials.

Schillerfeier

veranstaltet vom

Deutschen Lehrerverein von Cincinnati

in Verbindung mit

The University of Cincinnati, Board of Education,
und dem Oberlehrer-Verein.

Montag, den 8ten Mai, '05, Abends 8 Uhr,

in der

Aula der Universität.

The 100th anniversary of the death of German poet Schiller was cause for the Schiller Celebration, held at the University of Cincinnati, where the German Department had been established in 1900. Other area colleges and universities were also offering German programs by this time.

Jerry Glenn, professor emeritus of German at the University of Cincinnati, edited the *Lessing Yearbook*, published on German literature, and continues to edit occasional papers dealing with German American studies. He is one of the many scholars of the German Studies Department who have contributed to its international reputation.

The German-Americana Collection in the Blegen Library at the University of Cincinnati is considered the largest collection of its kind and attracts students and scholars from across the country, as well as Europe.

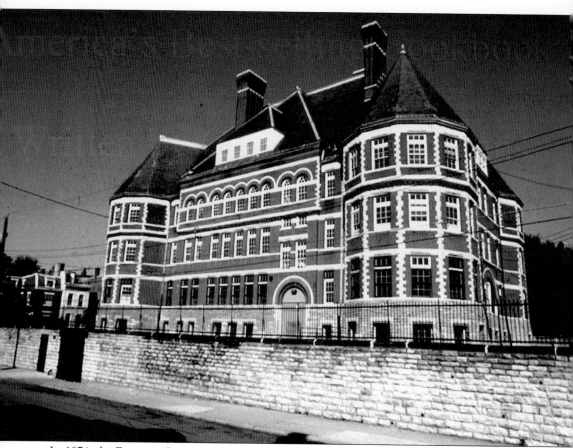

In 1974, the Fairview German Language School in Clifton became the first school in the area to re-introduce German instruction at the elementary school level after World War I. Since then, it has acquired a national reputation for educational excellence. Fairview maintains an exchange program with Donaueschingen in southern Germany and sponsors an annual German-American Day Program, as well as Fasching. Students continue their German studies at middle and high schools, and many then go on to the University of Cincinnati or other schools of higher education. The Tri-State German-American School in Covington also offers German instruction on Saturdays.

Six

BUSINESS AND INDUSTRY

Since the German element of the area is so large, it is not surprising that it has played a major role in the growth and development of business and industry in the region. Several factors above and beyond the statistical size of the German element contributed to its impact. Historically, German Americans have played an important part in areas that require vocational training and education. The existence in Germany of institutions for technical education no doubt was the principal cause here. In Germany, there is a two-track educational system, with one branch devoted to technical education in various trades and crafts. Here, for example, one would study and obtain a technical degree to enter the brewing trade as a brew master.

Another factor relates to the German tradition of the guild system. In this system, a youth would begin learning a trade as an apprentice, then become a journeyman, and finally graduate as a master of a particular trade. In the academic educational track, one would receive an educational diploma, whereas in the technical trade track one would have to complete an original project to prove one had mastered the trade. Also, each trade had its own particular seal, or coat of arms, that displayed the tools of the trade and signified pride in its practice.

Given these kinds of factors, many areas of business and industry can be identified where German Americans have exerted a great deal of influence; these range from brewing, banking, and baking to soap making and the machine industry.

German-style meat markets can be found throughout Greater Cincinnati.

Edelmann's was one of the many well-known meat-packing companies in the region. Some were noted for their particular specialties, such as Glier's of Covington for its goetta sausage.

Gerke's was one of the area's many German American breweries.

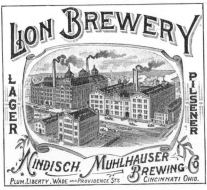

In 1866, Conrad Windisch and Heinrich and Gottlieb Muhlhauser founded the Lion Brewery, which was located at the intersection of what is now Liberty Street and Central Parkway. The building itself represented an outstanding example of German American brewery architecture, as it was constructed in the massive style of the Romanesque Revival.

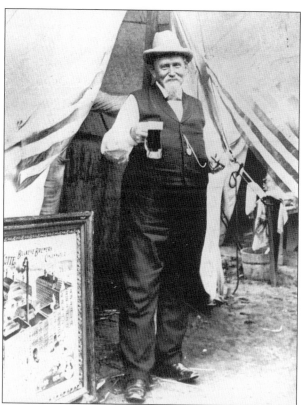

Ludwig Hudepohl, whose Hudepohl Brewing Company stood at 40 East McMicken Avenue, operated the largest brewing company in the area. It survived Prohibition by producing near-beer and soft drinks.

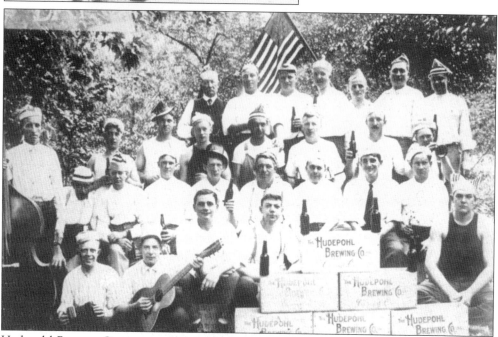

Hudepohl Brewery Company workers pose for a group photograph. The brewing industry was important for the local economy, as it employed many people and was the driving force among related businesses, including the bottling, restaurant, and entertainment industries.

The Moerlein Brewing Company produced some of the area's finest beers, including Barbarossa, Old Lager Beer, and Old Jug Lager. The latter was advertised as "exhilarating, stimulating, rejuvenating, wholesome, delicious, and pure."

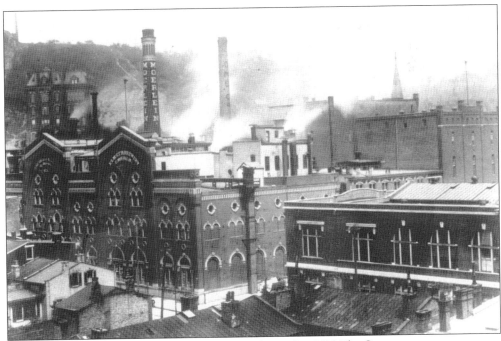

The Christian Moerlein Brewing Company was located at 2019 Elm Street.

KREBS LITHO. CO. CINCINNATI.

Situated on Dayton Street, the John Hauck Brewing Company was also considered one of the area's best breweries. Its beers included John Hauck Golden Eagle Lager, Export Lager, and Pilsner. Invalid Beer was even produced to improve the health of the weak and sickly. Hauck served as president of the German National Bank, located in downtown Cincinnati, which was renamed the Lincoln National Bank during World War I as a result of anti-German sentiment.

The Lunkenheimer Company, founded in 1862 by Frederick Lunkenheimer, a German-born machinist, provides but one example of the enormous impact Germans have had on the development of the region's machine industry. Located in Fairmount, the company became one of the nation's leading manufacturers of valves. In 1875, J. D. Kenny wrote, "Mr. Lunkenheimer was the first who obtained a patent on improvement in steam valves, and he enjoys a reputation second to none for the superiority and excellence of his brass castings. The trade extends over almost every state of the Union, and during the last four or five years, Mr. Lunkenheimer has made many shipments of his goods to various European countries."

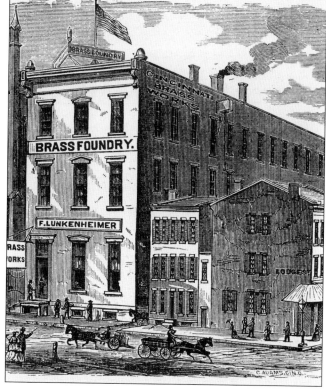

Alsation immigrant Michael Werk founded his own company specializing in candles and soap making. Werk Road in Westwood honors this first of Cincinnati's many "soap kings."

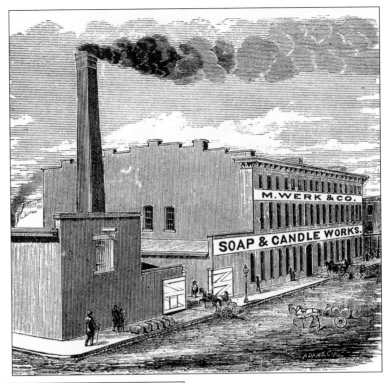

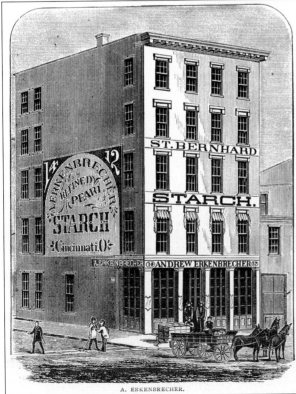

In 1859, Andreas Erkenbrecher established a starch factory in St. Bernard in an area that would become known as the site of the greatest concentration of factories for soap, cleansers, and candles, including Procter and Gamble. Starch produced by Erkenbrecher won recognition at international expositions in Bremen and Vienna.

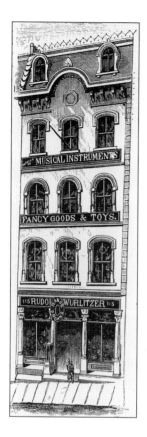

The Wurlitzer Company was founded by Rudolph W. Wurlitzer, a Saxon immigrant who arrived in Cincinnati with little more than a violin under his arm and a love for music. His company soon established a worldwide reputation for the manufacture of musical instruments. After World War II, it also acquired fame from the production of its ever-popular jukeboxes.

The anti-German sentiment of World War I caused many banks to change their names, as German Americans predominated in the area's banking and finance sectors.

Greater Cincinnati has one of the largest concentrations of building and loan firms, which is no doubt due to the German tradition of thriftiness. The term "building and loan" itself was derived from the German *Bauverein*, or building society. Founded in the 19th century, these institutions helped citizens save and provided loans to those interested in building a home. By 1950, there were 260 building and loans in Hamilton County and more than 30 south of the Ohio River in Kenton and Campbell Counties.

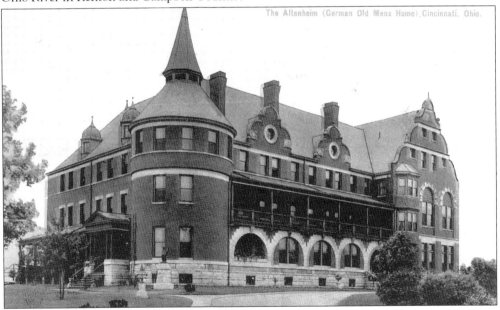

The area has benefitted greatly from the philanthropy practiced by German American businessmen and industrialists. A good example of this idea of giving back to the community was the *Altenheim*, established in 1891 as a home for elderly Germans. The names of its founders read like an honor roll of the German American business community: Alms, Schmidlapp, Moerlein, Wielert, Muhlhauser, Erkenbrecher, Markbreit, and Tafel. In its garden, an oak tree from Germany was planted in honor of Otto von Bismarck, who had played such an important role in the process of uniting Germany in the 19th century.

Driving in Cincinnati, one can sense the German impact on the area's business and industry by the names. Paging through the business section of the telephone directory reveals the same.

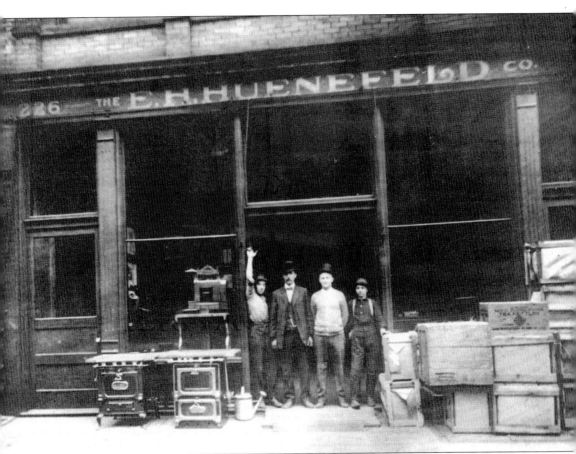

Born in 1838 in Ladbergen, Ernst H. Huenefeld founded the Huenefeld Company, invented the full-size glass door oven, and became famous for its manufacture. He helped incorporate Bethesda Hospital in 1896 and contributed generously to German Methodist causes. In 1908, Huenefeld donated his Clifton estate, now known as Scarlet Oaks, to Bethesda as a retirement home.

An Krogers Brot

KROGERS Brot ist weit und
breit
Bekannt durch seine Gütigkeit,
Wer dieses Brot einmal probiert
Dasselbe immer kaufen wird.

Esst alle Tage Krogers Brot,
Es macht die Wangen frisch
und rot,
Die besten Aerzte tun es kund,
Dies Brot sei nahrhaft und
gesund.

An diesem Brot spart jeder Geld
Und wird zufrieden stets ge-
stellt,
Dies Brot schmeckt wirklich
gut und fein,
Es könnte gar nicht besser sein.

Wenn dir dein Gatte und dein
Kind
Auf Erden lieb und teuer sind,
Dann, Hausfrau, merke dies
Gebot:
Kauf für dieselben KROGERS
Brot.

Bernard Kroger (1860–1938) was the founding father of one of the nation's largest grocery store chains, and his life was a German American success story. By means of hard work and dedication, Kroger rose from the position of delivery boy to store manager, and then on to owning his own grocery business. His stores, of course, catered to the tastes of German Americans, with the appropriate kinds of meats, breads, and beers.

Seven

CULTURAL

CONTRIBUTIONS

German Americans have contributed greatly to the cultural life of Greater Cincinnati. In the area of the arts, there have been many notables. Moreover, they have helped found institutions that foster an appreciation for and give an education in the arts. The impact of German American artists is quite evident in their religious creations that adorn many of the churches of the region.

The German impact on the world of music has been quite substantial. This goes back to the early emergence of German singing societies and the sponsoring of song festivals that helped lay the foundation for the May Festival and the eventual construction of the Music Hall, as well as the founding of the Cincinnati Symphony Orchestra. German Americans also played a role in musical education, starting with Clara Baur's founding of the Conservator of Music in 1867 and continuing in 1878 with the College of Music, directed by Theodor Thomas.

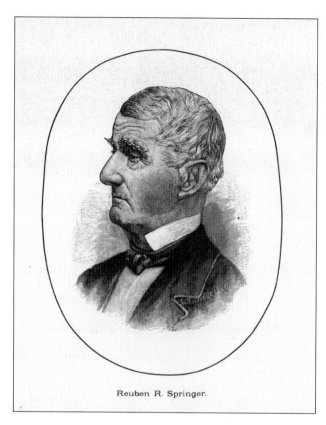

Reuben R. Springer.

Major funding for the Music Hall's construction was provided by Reuben Springer, who had made a fortune as a merchant in Cincinnati. Thanks to his philanthropic generosity, the Music Hall was completed in time for the celebration of the third May Festival in 1878. Springer was a third-generation German American whose immigrant grandfather had first settled in Virginia and then moved to Frankfort, Kentucky. The Music Hall, often referred to as the Springer Music Hall, took on the appearance of a German castle on the banks of Cincinnati's *Rhine*, or canal. Located directly in front of the building was Washington Park, the site of many German American festivals, and surrounding it were German churches, beer gardens, and saloons.

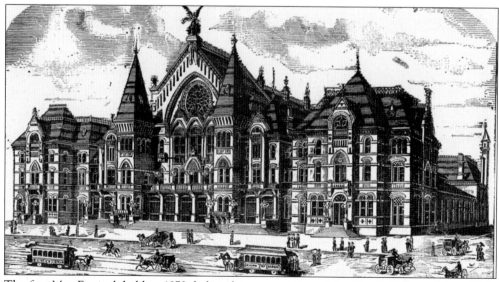

The first May Festival, held in 1873, led to the construction of the *Musik-Halle*, or Music Hall, which was completed in time for the third festival, in 1878.

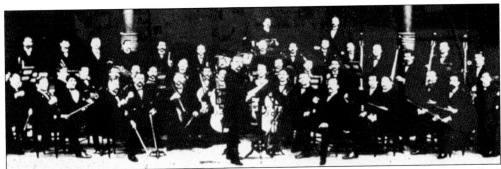

In 1895, the Cincinnati Symphony Orchestra was organized based on the nucleus of Michael Brand's orchestra, which played concert halls and beer gardens throughout Over-the-Rhine. It first played in Pike's Opera House and then moved into the Music Hall with Frank van der Stucken as conductor. Many German conductors followed him, and the current conductor of the Cincinnati's Pop Orchestra is the internationally known Erich Kunzel.

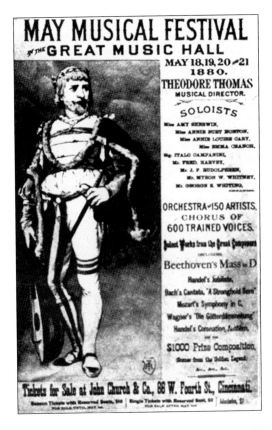

Theodore Thomas conducted Cincinnati's first May Festival and thereafter became its musical director, winning accolades and critical acclaim in the press. The *Chicago Times* claimed, "Poor Boston! Who shall recover her laurels? Westward the star of musical empire has taken its way, and it will never go back." Another report deemed the performance of Beethoven's Ninth Symphony "the greatest musical event of the age," and another claimed that "to have performed this symphony alone would have justified the Festival." The *Chicago Times* concluded, "Thomas was called for with as much enthusiasm as Beethoven would have seen at the first performance of the symphony in Vienna."

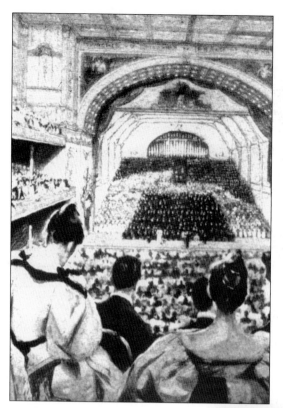

The choral tradition of Cincinnati's annual May Festival at the Music Hall can be traced to the German singing societies, which held the first Sängerfest in Cincinnati in 1849. German American singing societies from the Ohio Valley gathered and formed the *Nord-Amerikanische Sängerbund*, or North American Singers Federation, which celebrated its 150th anniversary in Cincinnati in 1999. The celebration was sponsored by the Kolping Sängerchor of Cincinnati

Emma Heckle sang as soloist at many May Festivals and concerts in the Music Hall, as well as across the country, and also offered musical instruction. In the 1890s, she was a guest of Cosima Wagner in Bavaria and stayed at Wagner's Bayreuth villa, Wahnfried, thereby demonstrating the recognition of German Americans in the musical world of the Old Country.

After hearing the beautiful voice of Jenny Lind, "the Swedish Nightingale," in Cincinnati in 1857, Samuel Pike was motivated to build a music hall. The German American, whose father had translated the family name Hecht to Pike, established Pike's Opera House in 1859, and his place attracted throngs for the next 44 years

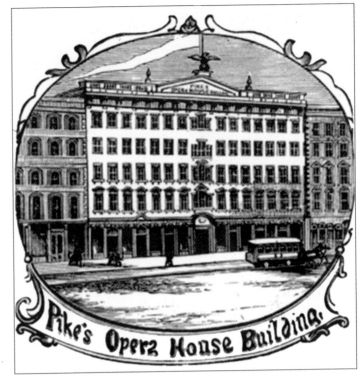

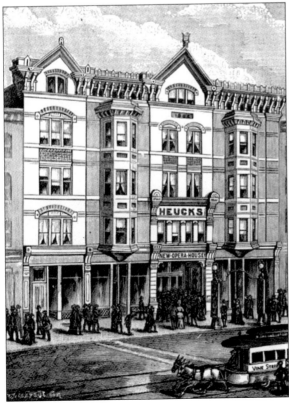

Popular musical and theatrical performances were offered by Hubert Heuck's Opera House, located at Thirteenth and Vine Streets in Over-the-Rhine. Max Burgheim described the place as "the most beautiful theater in Cincinnati. Mr. Heuck had spared neither cost nor effort to equip the elegant theater with all of the comforts and conveniences of the modern times, as well as taking care of the practical and artistic outfitting of the stage. . . . The formal opening of the beautiful house was a true event for Cincinnati, which long had felt sensitive about the lack of an elegant opera house. And it took only a short time before the prejudiced Americans, who would not readily attend a performance in a house Over-the-Rhine, were broken, and they came every evening together in the charming theater."

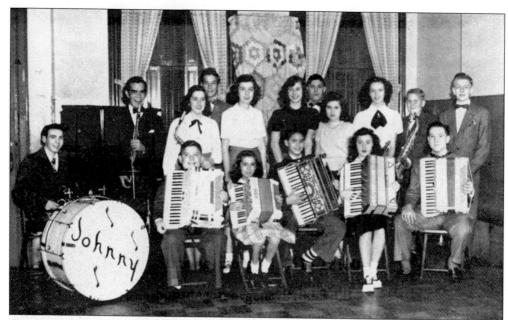

German American musical groups often presented programs. The Banater Junior Orchestra, the *Donauschwaben* group shown here, performed a concert at the Steuben Social Hall, Sterling and Simpson Avenues, North College Hill, on Sunday, December 14, 1947.

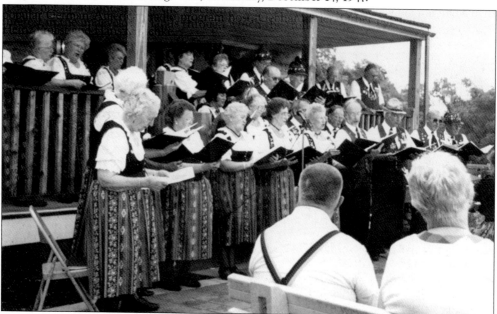

The Kolping Sängerchor was formed in 1989, when singers "united in common bond for their love of German music while preserving the heritage of the singing societies in the Cincinnati area," according to one of its musical programs. Since that time, the choir has performed at national and regional Sängerfeste, at the Music Hall, and at various German American events like German Day. The group sponsors spring and Christmas concerts and an annual Schlachtfest. The Sängerchor has also toured Germany, bringing German American musical programs to the Old Country.

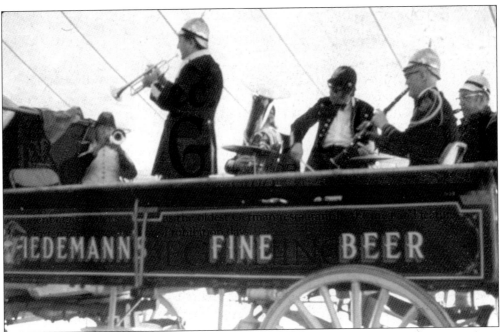

Pete Wagner's Schnapps Band is one of the many popular German American bands in the area.

The Cincinnati Art Museum, opened in Eden Park in 1886, is well known for its fine exhibits and educational programs. Especially important for the German heritage is its collection of German American art by Frank Duveneck, who donated his works to the museum before his death in 1919. Alvin F. Harlow described Duveneck as "a great teacher, beloved by his pupils; his round head, big moustache and eyes gleaming through spectacles were like those of a German professor of philosophy, though he had an unprofessorial joviality, a love of a baseball game or a long hour or talk over beer and a bite at Foucar's. He did every sort of paining well, though he had a particular fancy for figures. . . . In his earlier period, he worked mostly in the brown tints of the seventeenth century Dutch masters whom he so greatly admired; but after a visit to the brilliant skies and florid scenes of Italy, his work became more colorful, and this newer manner continued throughout his life."

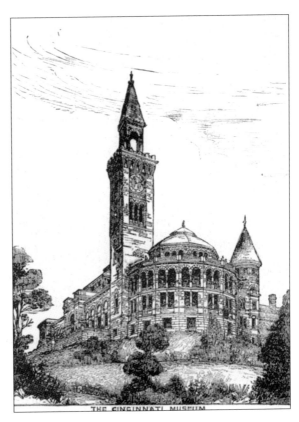

THE CINCINNATI MUSEUM

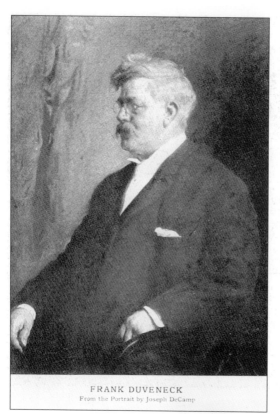

FRANK DUVENECK
From the Portrait by Joseph DeCamp

Fellow artist John Singer Sargent called Frank Duveneck "the greatest talent of the brush in this generation." Born in Covington in 1848, Duveneck worked with various German American church art decorators before attending the art academy in Munich. There, he studied the work of Rubens and Van Dyck and, in 1874, held a successful show in Cincinnati before returning to Munich, where he established his own school and a following known as the "Duveneck Boys." In 1890, he began his teaching career at the Cincinnati Art Academy. In Covington, the Duveneck Arts and Cultural Center has been established at the Duveneck home at 1232 Greenup Street.

John Hauser was another well-known German American artist of the area, who studied in Munich and Düsseldorf. Hauser visited American Indian reservations, particularly those of the Sioux, and focused on depicting them in his many paintings. As shown in this photograph, Hauser also had a predilection for western garb.

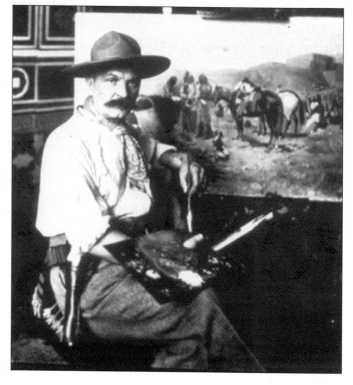

This historical marker is located at the Holy Cross–Immaculata Church in Mount Adams. The interior murals by Johann Schmitt, Duveneck's teacher, represent some of the most beautiful church art in the entire region.

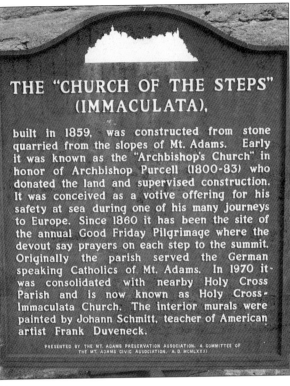

THE "CHURCH OF THE STEPS" (IMMACULATA),

built in 1859, was constructed from stone quarried from the slopes of Mt. Adams. Early it was known as the "Archbishop's Church" in honor of Archbishop Purcell (1800-83) who donated the land and supervised construction. It was conceived as a votive offering for his safety at sea during one of his many journeys to Europe. Since 1860 it has been the site of the annual Good Friday Pilgrimage where the devout say prayers on each step to the summit. Originally the parish served the German speaking Catholics of Mt. Adams. In 1970 it was consolidated with nearby Holy Cross Parish and is now known as Holy Cross-Immaculata Church. The interior murals were painted by Johann Schmitt, teacher of American artist Frank Duveneck.

PRESENTED BY THE MT. ADAMS PRESERVATION ASSOCIATION, A COMMITTEE OF THE MT. ADAMS CIVIC ASSOCIATION. A.D. MCMLXXXI

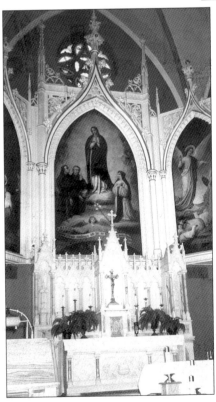

Seen here are Schmitt's murals at the Holy Cross–Immaculata Church.

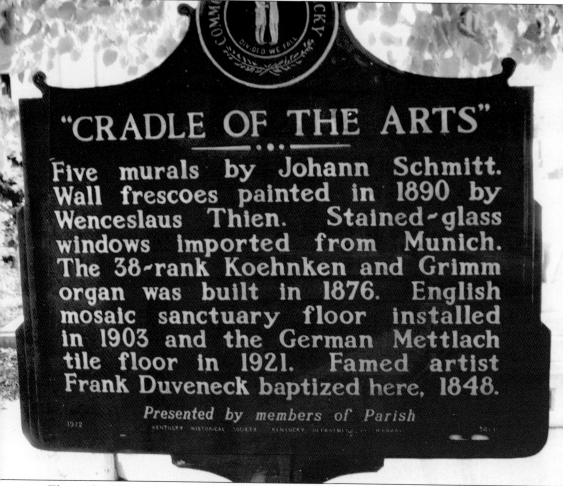

"CRADLE OF THE ARTS"

Five murals by Johann Schmitt. Wall frescoes painted in 1890 by Wenceslaus Thien. Stained-glass windows imported from Munich. The 38-rank Koehnken and Grimm organ was built in 1876. English mosaic sanctuary floor installed in 1903 and the German Mettlach tile floor in 1921. Famed artist Frank Duveneck baptized here, 1848.

Presented by members of Parish

1972 KENTUCKY HISTORICAL SOCIETY KENTUCKY DEPARTMENT OF HIGHWAYS

The work of German American artists adorns many churches in the area, such as the *Mutter Gottes Kirche* in Covington. These artists not only provided the paintings, sculptures, and wood carvings, but also decorated altars and even entire church buildings. Several churches with murals by Duveneck's student, Leon Lippert, are located in northern Kentucky: St. Joseph Church in Camp Springs, Corpus Christi Church in Newport, and Sacred Heart Church in Bellevue.

Eight

NEWSPAPERS, JOURNALS, AND AUTHORS

Since the 19th century, Greater Cincinnati has been one of the major centers of German American press and literature. Approximately 200 German American newspapers and journals have been published, and close to 2,000 German-language imprints came off the German American press of the area. These German American publications were widely read throughout the Midwest, and their newspaper editorials were often cited and reprinted in St. Louis, Milwaukee, and elsewhere.

The Cincinnati German press began with the publication of an almanac, *Teutscher Calender auf 1808*, and followed with numerous newspapers and journals. In 1910, the two major newspapers, the *Volksblatt* and the *Freie Presse*, had a combined circulation of 110,000. German American newspapers provide an excellent source of information on regional history, and fortunately several of the major ones have been indexed.

After the mid-20th century, the German American press by and large made a language shift from German to English, although some publications continue to include German-language materials. Many also made the transition from the newspaper format to the more economical newsletter. Nonetheless, German-language newspapers published in this country continue to circulate in the area, especially the *Amerika-Woche*.

The writings of German American authors include those in the German and English languages and cover the entire spectrum of fields and disciplines, but especially historical and literary works, many of which relate to the region. Today, several German American novels from the area are considered classics. These include *Cincinnati, or the Mysteries of the West* by Emil Klauprecht and *Wooden Shoe Hollow* by Charlotte Pieper.

Commencing publication in 1836, the *Volksblatt* quickly became one of the leading German American newspapers of the Midwest. Like German American newspapers elsewhere, it was hard hit by the anti-German hysteria of World War I, which caused advertising and newsstand boycotts. After the war, it made a gallant but futile attempt to rebuild. Newspapers could no longer advertise for the brewing industry due to Prohibition and thus suffered the loss of a major source of revenue. On December 5, 1919, the *Volksblatt* published its last issue after having been purchased and absorbed by the other local newspaper, the *Freie Presse*. Fortunately, an index is available of this important newspaper: Jeffrey G. Herbert's *Index of Death Notices Appearing in the Cincinnati Volksblatt, 1846–1918* (1998).

... Die ...
„Tägliche freie Presse"

erscheint jeden Morgen und ist die größte, beste und reichhaltigste Morgenzeitung in Cincinnati.

Sie lobt, was zu loben, und tadelt, was zu tadeln ist, ohne Unterschied der Person oder der Partei. Sie ist bekannt als die deutscheste Zeitung Amerikas und bringt alle Neuigkeiten in völlig unparteiischer Weise. In dem jetzigen Weltkriege hat die „freie Presse" von Beginn der Feindseligkeiten an furchtlos auf seiten Deutschlands gestanden, und sie verficht mit aller Energie das gute Recht unseres alten deutschen Vaterlandes allen dessen Feinden gegenüber.

Die „freie Presse" wird jeden Morgen im Hause der Abonnenten durch die Träger abgeliefert und kostet **12 Cents per Woche.**

224

The *Freie Presse*, established in 1874, published daily and Sunday editions and rose as the major German American newspaper of the post–World War I era. In 1962, it was absorbed into a new newspaper, the *Cincinnati Kurier*, which was published until 1982, when it was in turn absorbed by a weekly, the *Amerika-Woche*, currently published out of Freeport, New York, with a national circulation.

The former office of the *Freie Presse* is located on Vine Street, across from the Cincinnati Public Library. For information on this newspaper, consult Jeffrey G. Herbert's *Index of Death and Other Notices Appearing in the Cincinnati Freie Presse, 1874–1920* (1993).

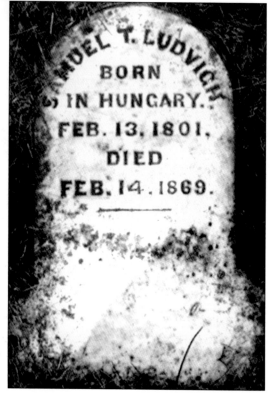

Samuel Ludvigh (1801–1869), buried in Spring Grove Cemetery, edited several German American journals, along with authoring several books. Generally known as the *Fackelträger*, or "Torch Bearer," Ludvigh was especially notable for his free thought views on a wide variety of topics.

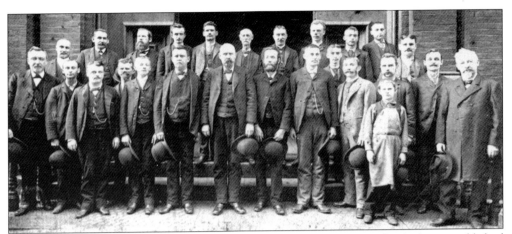

This 1889 photograph shows the printers of the *Cincinnati Volksfreund*, which was published from 1850 to 1908. For an index to this newspaper, see Jeffrey G. Herbert's *Index to Death Notices and Marriage Notes Appearing in the Cincinnati Volksfreund, 1850–1908* (1991).

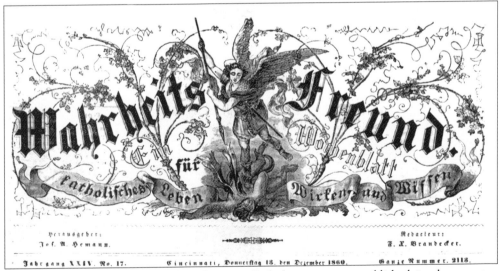

The *Wahrheits-Freund* was the first German Catholic newspaper published in the country, appearing from 1837 to 1907. A valuable source of information, it unfortunately has not yet been indexed.

Emil Klauprecht (1815–1896) edited several German American newspapers and journals, but is especially well known for his literary and historical work. *Cincinnati, or the Mysteries of the West* is a novel of German American life in Cincinnati before the Civil War. Klauprecht also published the first history of the German element in the Ohio Valley: *German Chronicle in the History of the Ohio Valley, and its Capital City, Cincinnati in Particular.* He aimed to document and record German American history, stating, "A people can expect respect from their neighbors and sacrificing friends and benefactors among them, only when they themselves honor the great deeds and merits of their forebears and pass them on from generation to generation."

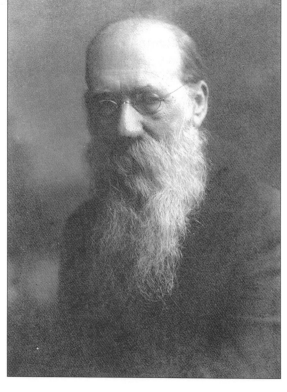

Heinrich A. Rattermann (1832–1923) edited two historical journals, *Der Deutsche Pionier* and *Deutsch-Amerikanisches Magazin*, which provide a wealth of information relating to the region's German heritage. At his 510 York Street home in the West End, he typeset the entire 12 volumes of his collected works, *Gesammelte ausgewählte Werke.* These contain his historical and literary achievements, including his more than 600 poems, the most famous of which was "Vater Rhein."

Rattermann's German Mutual Insurance Company, which changed its name to the Hamilton Life Insurance Company during World War I, was located at Twelfth and Walnut Streets in the Over-the-Rhine district. During the war, the Germania Building was renamed the Columbia Building, but thereafter reverted to its original name. A statue of Germania, the personification of German culture, adorns the building, which itself served as a tribute to the German heritage.

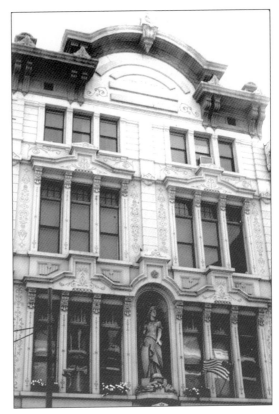

Deutscher Pionier-Verein

Cincinnati, Ohio

Gegründet 1868

VORSTANDS-BERICHT

87. Vereinsjahr 1954—1955

BEAMTE DES VEREINS 1954—1955

Vorstand Christ Weishaupt, 5501 Springdale Road

2. Vorstand Wm. Hofmann, 3249 Epworth Avenue

Schriftführer Hugo Ohl, 454 Fairview Place

Schatzmeister Clemens Jörling, 2325 Stratford Ave.

Kollektor Nick Schäfer, 3125 Spruce Drive

Verwaltungsrat Nick Rapp, Paul Lohs

Lebender Ex-Vorstand Herman Forsten

Ehrenmitglieder Karl Pressler, Gustav Darneron, Chas. E. Menier, Karl Becker

The German Pioneer Society, or *Deutscher Pionier-Verein*, was founded after the Civil War to record German American history. Centered in Cincinnati, it also had branches in Covington and Newport. The society published the journal *Der Deutsche Pionier*, edited by Heinrich A. Rattermann.

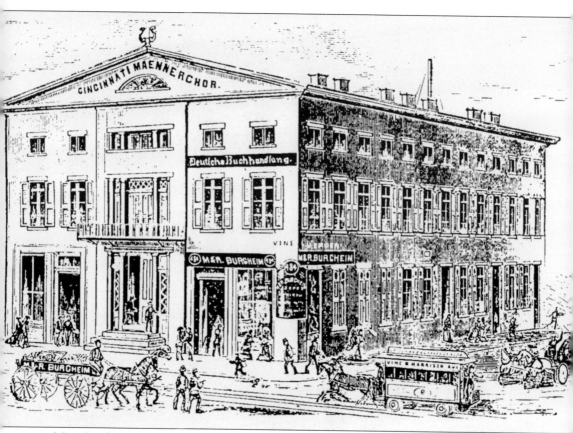

Max Burgheim (1849–1935) operated this German American bookstore and also published several books dealing with the German heritage of the area, including *Cincinnati in Wort und Bild*. From 1904 to 1918, he also published the *Freie Presse*.

Nu fünd wi in Amerika.

En plattdütfch Riemels

von

Carl Münter.

1878.

Schnellpreffen Druck von Bloch u. Co.,

Cincinnati, O.

This book of German American poetry in *Plattdeutsch*, or Low German, bears the stamp of its owner, Dr. H. H. Fick, who amassed a large private library of German American materials that was acquired by the University of Cincinnati Libraries after his death in 1935. The Fick Library became the foundation for the German-Americana Collection, established at the university in 1974 and today one of the largest such collections.

America's Best-selling Cookbook

Written by German-Americans

Great Living Cincinnatians

Marion R. Becker **Awarded in 1976**

Marion R. Becker became the area's major best-selling German American author as coauthor with her mother, Irma Rombauer, of the well-known *Joy of Cooking*. Their famous cookbook begins with the following quotation from Goethe's *Faust*: "That which thy fathers have bequeathed thee, / Earn it anew, if thou wouldst possess it."

Nine

WAR AND POLITICS

German Americans have been actively involved in politics from the very beginning, with Maj. David Ziegler serving as Cincinnati's first mayor in 1802. Moreover, they have played an important role in the area of military service, especially during the Civil War, and the service rolls have always reflected a high percentage of German surnames.

Anti-German hysteria and sentiment accompanied both world wars, with World War I being especially difficult for German Americans, as well as for all things generally German. In addition, Prohibition wreaked havoc not only on the brewing industry, but also on German American social life. German immigration increased in the postwar era, however, and the social and cultural calendar of German American festivities and activities was again on the upswing by the 1950s.

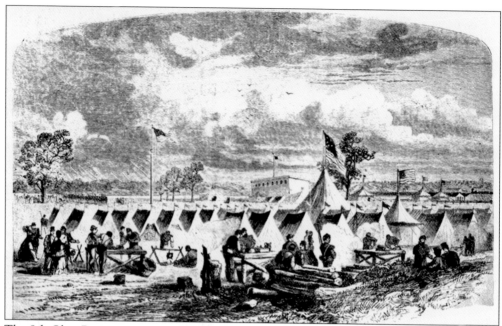

The 9th Ohio Regiment, one of the four Cincinnati German regiments during the Civil War, first trained at Fort Harrison, located in the Cincinnati Trotting Park on the outskirts of Cumminsville. A local newspaper described the regiment, which consisted of members of the Cincinnati Turnverein, as follows: "The first company of the Turner men were solid as heart pine and as supple as antelopes. They passed the examination ordeal solidly and lost not a man. As the army surgeon struck their chests they sounded like so many anvils," according to Constantin Grebner's *We Were the Ninth.*

A Forty-Eighter and the supposed illegitimate son of a Hohenzollern prince, August von Willich (1810–1878) studied at a Prussian military academy before entering the Prussian army as captain of the artillery. His participation in the 1848 Revolution caused him to immigrate to America and settle down in Cincinnati, where he edited the German American newspaper *Der Deutsche Republikaner.* In April 1861, he joined the 9th Ohio Regiment, becoming its drill master. He also organized another German American unit, the 32nd Indiana Regiment, which took those who could not get into the 9th. Both were considered outstanding Civil War regiments.

A monument at Chickamauga honors the 9th Ohio Regiment.

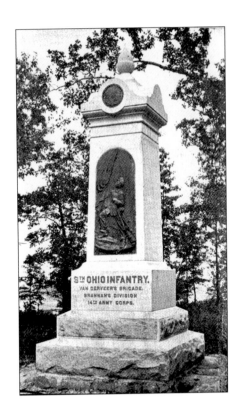

German Units from Cincinnati – Civil War

Infantry: 4 regiments
- 9th Ohio Inf.
- 28th Ohio Inf.
- 106th Ohio Inf.
- 108th Ohio Inf.

Artillery: 3 batteries
- Dilger's Battery, Battery 1, originally from von Dammert's Battery
- Hofmann's Battery, 4th Ohio Battery

German American support for the cause of the Union was great.

After the Civil War, German Americans played an active role in area politics. Many entered the practice of law and conducted their cases in German.

Col. Gustav Tafel (1830–1908), a Forty-Eighter, helped found the Cincinnati Turnverein and edited the *Cincinnati Volksblatt*. During the Civil War, he served in the 9th and 106th Ohio Regiments, rising to the rank of colonel. After the war, he served in the Ohio State Legislature and was elected mayor of Cincinnati, a position he held from 1897 to 1900. Like most German American politicians, he supported German instruction in the schools and strongly opposed Prohibition.

After the start of World War I in August 1914, German Americans did their best to present their position on the war, as they felt that the English-language press was pro-British and anti-German, especially after the transatlantic report that the British had cut the international news cable. All news relating to the war thereafter came from Britain. Moreover, individuals of Anglo-American descent dominated President Wilson's administration, so it was not surprising where their sympathies lay, especially when Wilson's pro-British position was so well known. Judge John Schwaab served as president of the German-American Alliance, which did its utmost to advance the cause of American neutrality. It also raised a substantial amount of funds for war relief programs for the sick, needy, and orphaned in Germany and Austro-Hungary.

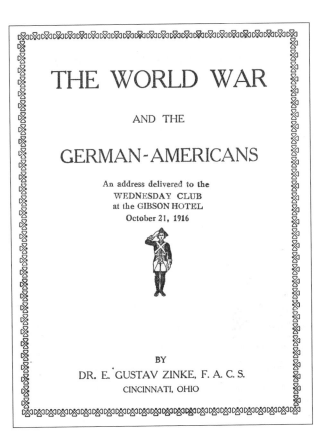

THE WORLD WAR

AND THE

GERMAN-AMERICANS

An address delivered to the
WEDNESDAY CLUB
at the GIBSON HOTEL
October 21, 1916

BY
DR. E. GUSTAV ZINKE, F. A. C. S.
CINCINNATI, OHIO

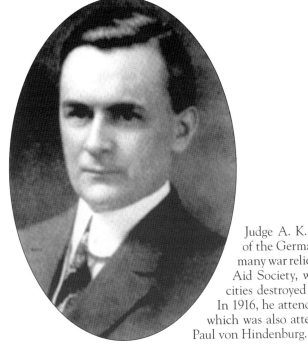

Judge A. K. Nippert, a widely respected member of the German American community, served with many war relief societies, including the East Prussian Aid Society, which raised funds for the towns and cities destroyed by the Russian army in East Prussia. In 1916, he attended the society's convention in Berlin, which was also attended by Kaiser Wilhelm II and Gen. Paul von Hindenburg.

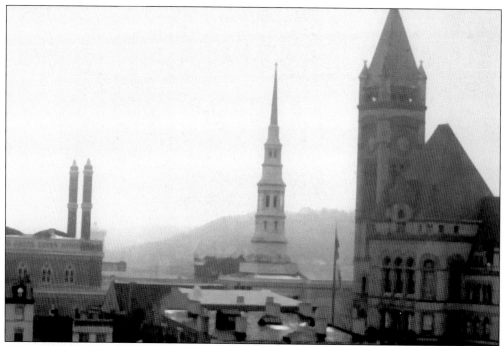

Swept up into the anti-German hysteria of the time, the Cincinnati City Council passed an ordinance on April 9, 1918, changing street names that bore associations with Germany or Austria.

During World War I, Bremen Street in Over-the-Rhine was changed to Republic Street, but the name changers could not even spell "Republic" correctly.

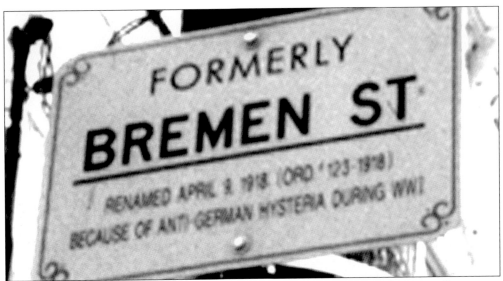

As a result of a request from the German-American Citizens League of Greater Cincinnati, in 1995 the city placed informational signs on all the former German streets that had been changed in 1918. This was done to remember the wrongs and injustices of World War I.

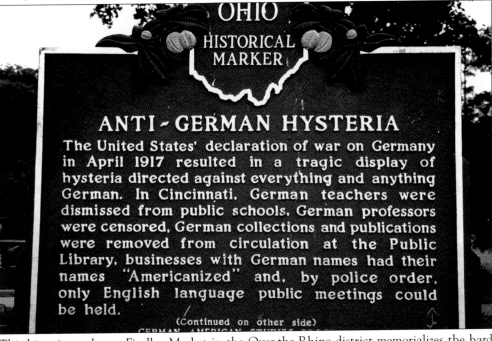

OHIO
HISTORICAL MARKER

ANTI-GERMAN HYSTERIA

The United States' declaration of war on Germany in April 1917 resulted in a tragic display of hysteria directed against everything and anything German. In Cincinnati, German teachers were dismissed from public schools, German professors were censored, German collections and publications were removed from circulation at the Public Library, businesses with German names had their names "Americanized" and, by police order, only English language public meetings could be held.
(Continued on other side)

This historic marker at Findlay Market in the Over-the-Rhine district memorializes the hard times of World War I. The inscription on the other side reads, "As a result of the anti-German hysteria during World War I, name changing became the rage. The Cincinnati City Council followed the trend by changing German street names on April 9, 1918. Among those changed were: German Street to English Street, Berlin Street to Woodrow Street, Bremen Street to Republic Street, Brunswick Street to Edgecliff Point, Frankfort Street to Connecticut Street, Hanover Street to Yukon Street, Hapsburg Street to Merrimac Street, Schumann Street to Meredith Street, Vienna Street to Panama Street, and Humboldt Street to Taft Road."

A movement to expel Dr. Gotthard Deutsch of Hebrew Union College because of his anti-war views resulted in the censure of the learned professor.

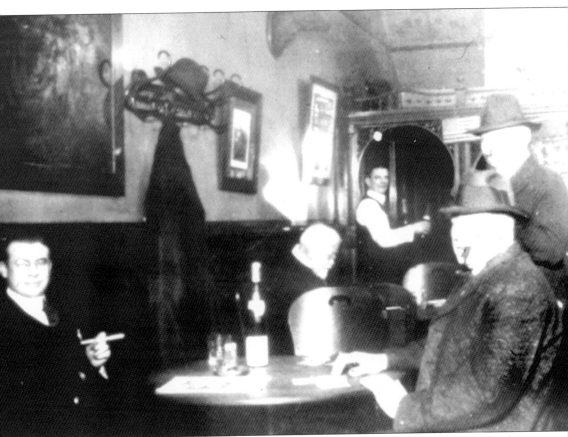

German Americans soon faced Prohibition, which lasted from January 16, 1920, to December 5, 1933. Before the law took effect, the German-American Citizens League sponsored a huge beer fest as "a brilliant wake" to the end of the beverage. With the repeal of Prohibition, war clouds loomed again on the horizon as the Third Reich rose to power. German Americans took a strong stance against the German-American Bund and barred it from participating in the annual German Day celebrations. After World War II, German Americans raised funds for the postwar relief of Germany and Austria.

The officers of the German-American Citizens League provided community leadership in the postwar era and also actively promoted humanitarian relief projects on behalf of Germany. After the war, almost $50,000 and 20,000 pounds of clothing were collected for the needy in Germany, and in 1950, a concert at the Music Hall raised more than $10,000.

Ten

GERMAN HERITAGE REVIVAL

Since the 1970s and 1980s, German Americans across the country have experienced what has been described as the German heritage revival. Part of the wave of interest in ethnic heritage, "roots," and genealogy sweeping the country, this increased interest has found expression in the celebration of Oktoberfest by the cities of Cincinnati, Covington, and Newport. Also, the Fairview German Language School was established in 1974, bringing back German instruction to the elementary-school level for the first time since the pre–World War I era.

German American societies flourish, offering a wide variety of festivities and activities throughout the year, and in 2000 the German Heritage Museum was established to highlight German contributions to the region. The German-American Studies Program at the University of Cincinnati offers courses dealing with the unique German American experience, and its German-Americana Collection in the Blegen Library provides a wealth of materials for research and study. Moreover, several historical markers have been dedicated, demonstrating the widely held sense of public pride in this heritage. Restaurants and beer gardens provide plenty of *Gemütlichkeit* for locals and visitors as well.

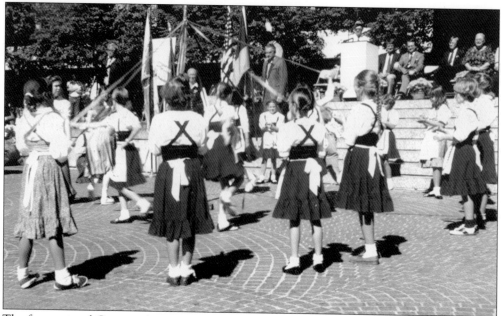

The first national German-American Day celebration was held on Fountain Square on October 6, 1987, and was sponsored by the German-American Citizens League. Since 1989, the league has also sponsored German-American Heritage Month in October, with a month-long program of lectures, exhibits, and activities focusing on the role played by German Americans in the region's history.

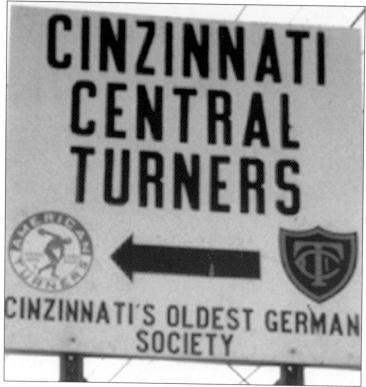

The Cincinnati Central Turners is the oldest German American society in the area, as well as the first Turner society in the country. In 1948, the U.S. Post Office issued a commemorative stamp in honor of the centennial of the Turners. Bearing the Turner motto of "Sound Mind & Sound Body," the stamp is now a collector's item.

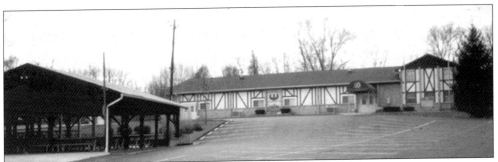

The Donauschwaben Society, located on Dry Ridge Road in Colerain Township, sponsors a variety of festivities and activities, including German classes and an ever-popular Oktoberfest.

Founded in 1924, the Kolping Society, based on Mill Road, is responsible for the annual Schuetzenfest, the oldest German festival in Cincinnati. Recently, a Low German group has been formed, in which the many members of North German stock speak *Plattdeutsch*.

The Germania Society, situated on West Kemper Road in Colerain Township, was founded in 1964 and sponsors various festivities and activities, including the annual Christkindlmarkt and its outstanding Oktoberfest.

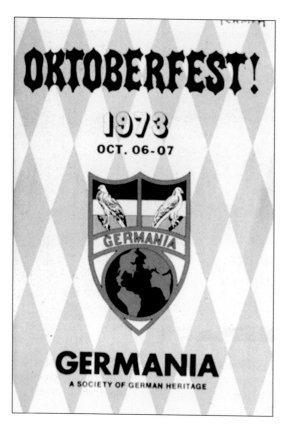

In 1971, the Germania Society sponsored the area's first Oktoberfest.

The German Genealogical Group of the Hamilton County Genealogical Society displays publications relating to German American genealogy at various German American events.

The Cincinnati Wood Carvers Guild displays its wares at German American events, such as the St. Nicholas Day celebration at the German Heritage Museum. Some of its members have even studied woodcarving in Germany and Austria.

Oktoberfest Zinzinnati has been celebrated in downtown Cincinnati since 1976. The event is sponsored by the downtown council in cooperation with the German-American Citizens League, which first suggested the idea of an Oktoberfest as a way to celebrate German heritage during the American bicentennial year of 1976.

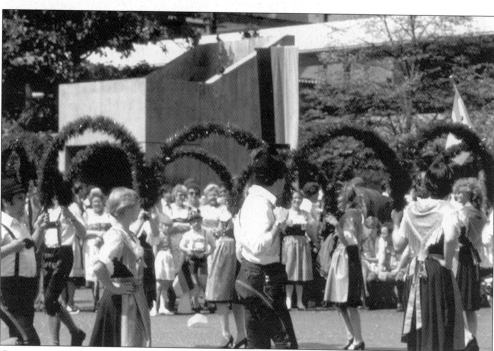

German dance groups, such as the Enzian Tanzgruppe, perform at the downtown Oktoberfest.

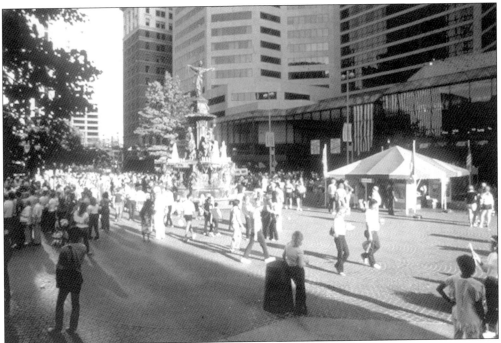

Fountain Square is pictured during the annual downtown Oktoberfest, which attracts more than a half-million people to Cincinnati every year.

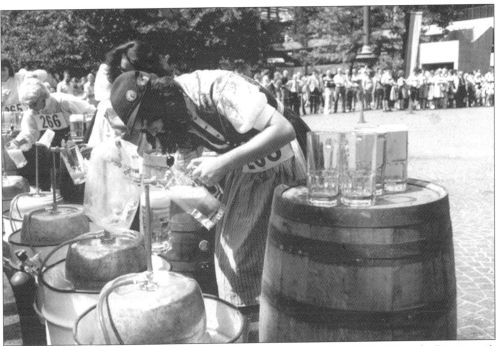

Cincinnati's Oktoberfest is the second largest in the world after that held in Munich, Cincinnati's sister city.

By the 1970s, German American radio programs had become popular in the area, broadcasting German music and providing news about community events. This advertisement features a popular German American radio program host, Gebhard Erler. Other popular hosts included Heinz Probst and Hans Kroschke.

Across the Ohio River in Covington, the annual Covington Oktoberfest in MainStrasse German Village attracts more than 100,000 people and usually takes place a week before Cincinnati's downtown Oktoberfest. Mick Noll (in the center with Lederhosen), long active in Covington German affairs, welcomes festival goers in this photograph.

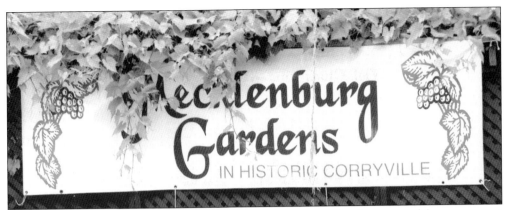

Mecklenburg Gardens thrives as the oldest German restaurant in the area and features a great *Bier Garten* reminiscent of pre-Prohibition days.

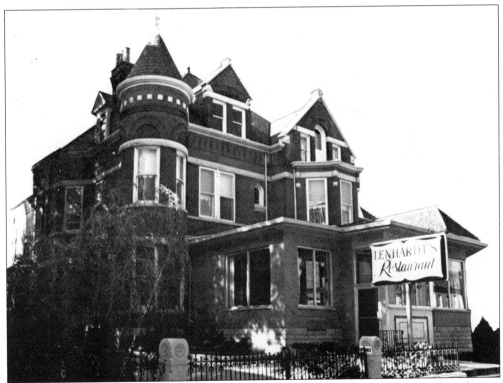

Lenhardt's Restaurant is located in the former home of a Cincinnati German beer brewer bordering on the south edge of the University of Cincinnati. It also has a *Ratskeller* and a *Bier Garten*. Its specialty lunches include a tasty homemade *Wurst* with mashed potatoes and sauerkraut, known locally as "German soul food."

In 2005, the Hofbräuhaus Newport dedicated its colorfully decorated Maibaum.

The Hofbräuhaus Newport, well known for its fine food and beers, is attractively situated on the banks of the Ohio River in Newport.

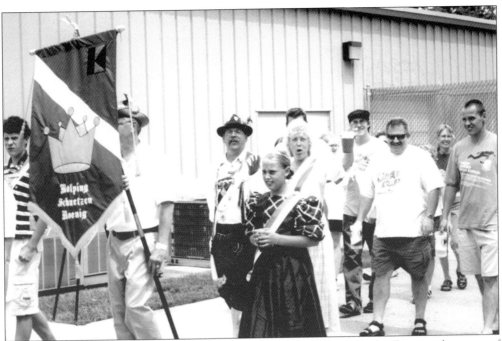

The 2005 Schuetzenfest parade of the Kolping Society featured the king and queen of 2004–2005: Pat and Irene Whalen.

Members of German American societies prepare for the opening parade of Cincinnati's downtown Oktoberfest.

Sponsored by the German-American Citizens League of Greater Cincinnati, the German Heritage Museum opened in 2000 and attracts visitors and school groups from near and far.

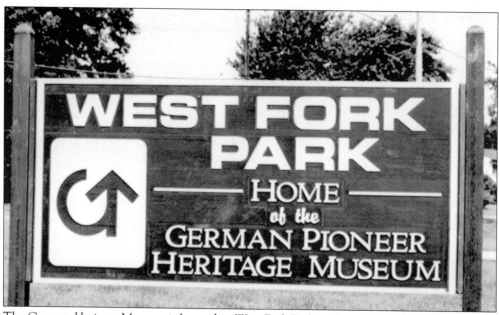

The German Heritage Museum is located in West Fork Park in Green Township.

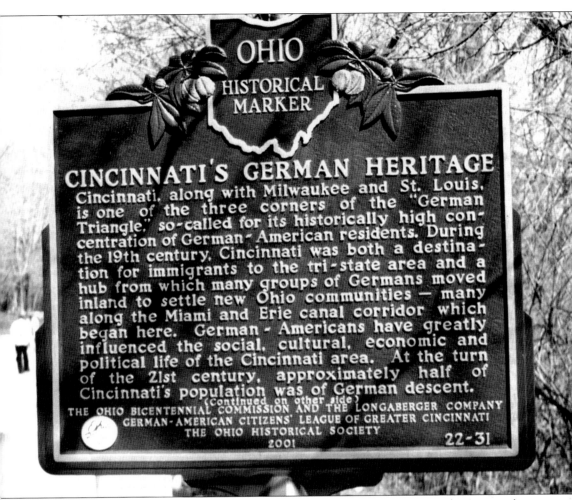

OHIO HISTORICAL MARKER

CINCINNATI'S GERMAN HERITAGE

Cincinnati, along with Milwaukee and St. Louis, is one of the three corners of the "German Triangle," so-called for its historically high concentration of German-American residents. During the 19th century, Cincinnati was both a destination for immigrants to the tri-state area and a hub from which many groups of Germans moved inland to settle new Ohio communities — many along the Miami and Erie canal corridor which began here. German-Americans have greatly influenced the social, cultural, economic and political life of the Cincinnati area. At the turn of the 21st century, approximately half of Cincinnati's population was of German descent.
(Continued on other side)

THE OHIO BICENTENNIAL COMMISSION AND THE LONGABERGER COMPANY
GERMAN-AMERICAN CITIZENS' LEAGUE OF GREATER CINCINNATI
THE OHIO HISTORICAL SOCIETY
2001 22-31

This historic marker, placed at Sawyer Point along the Ohio River, conveniently sums up the basic points about the area's German heritage.

FOR FURTHER READING

For works on the German heritage of Greater Cincinnati, consult the following works by the author: *Festschrift for the German-American Tricentennial Jubilee* (Cincinnati: Cincinnati Historical Society, 1982); *Cincinnati's German Heritage* (Bowie, MD: Heritage Books, 1994); *Covington's German Heritage* (Bowie, MD: Heritage Books, 1998); and *German Heritage Guide to the Greater Cincinnati Area* (Milford, Ohio: Little Miami Publishing, 2003). Also see Mary Edmund Spanheimer's *The German Pioneer Legacy: The Life and Work of Heinrich A. Rattermann*, second edition, edited by Don Heinrich Tolzmann (Oxford: Peter Lang, 2004) for the biography of Rattermann, who published a great deal on the German American history of the region prior to World War I.

For two German American novels dealing with the region, read Emil Klauprecht's *Cincinnati, or, the Mysteries of the West: Emil Klauprecht's German-American Novel,* translated by Steven Rowan and edited by Don Heinrich Tolzmann (New York: Peter Lang Publishing, 1996), and Charlotte Pieper's *Wooden Shoe Hollow*, second edition, edited by Don Heinrich Tolzmann (Milford, Ohio: Little Miami Publishing, 2004).

For the history of German immigration and settlement in the Ohio River Valley, consult *Kentucky's German Heritage: H. A. Rattermann's History*, translated and edited by Don Heinrich Tolzmann (Bowie, MD: Heritage Books, 2001), and the author's *German Heritage Guide to the State of Ohio* (Milford, Ohio: Little Miami Publishing, 2005).

All of the aforementioned works contain bibliographies for primary and secondary sources in English, as well as German for those interested in a more in-depth exploration of a particular topic. In addition, readers may want to consult some of the excellent libraries in the area, such as the Campbell County Public Library, the Cincinnati Historical Society, the Clermont County Public Library, the Hamilton County Public Library, the Kenton County Public Library, and especially the German-Americana Collection at the University of Cincinnati.

Images from this book are from the author's collection, the collection of Kevin Grace, and the German-Americana Collection and Photographic Services at the University of Cincinnati.